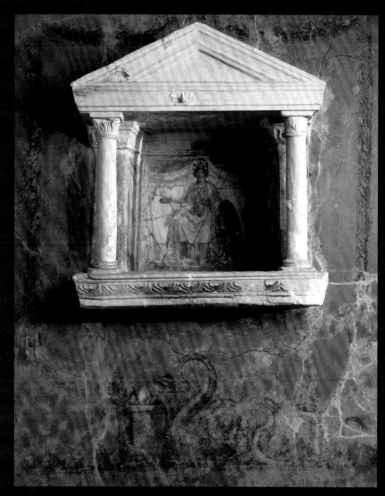

HOUSEHOLD GODS

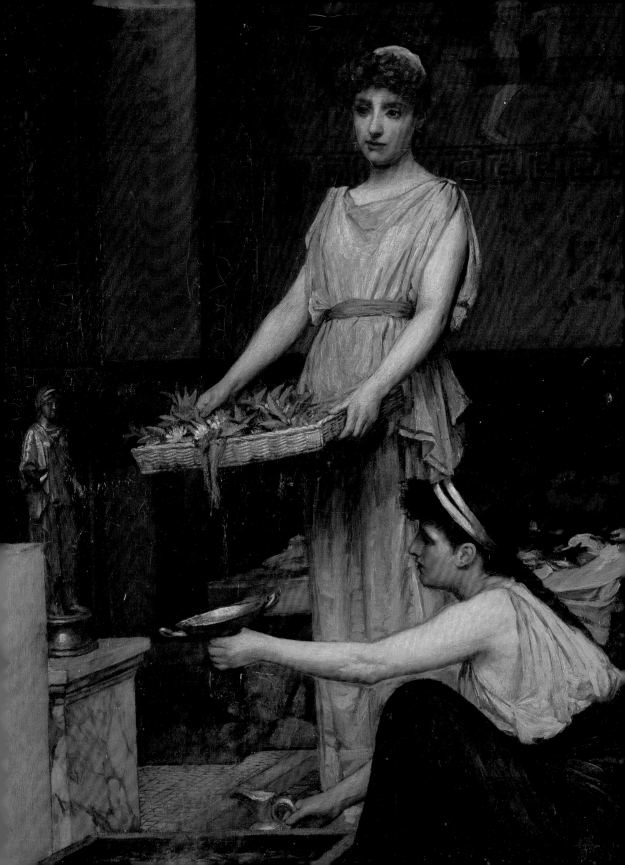

Household
Gods

PRIVATE DEVOTION IN
ANCIENT GREECE AND ROME

Alexandra Sofroniew

THE J. PAUL GETTY MUSEUM

LOS ANGELES

CONTENTS

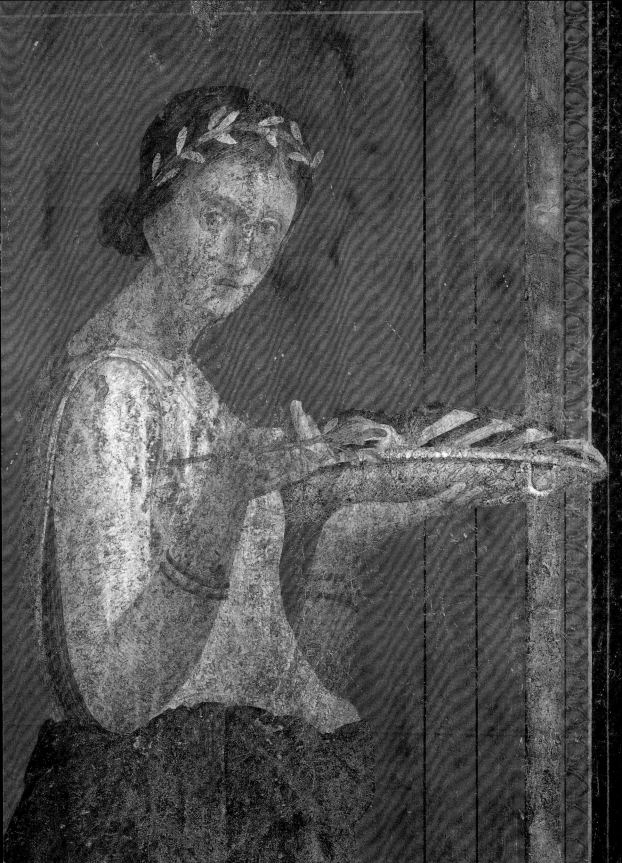

CHRONOLOGY

Greek

Geometric 900–700 B.C.

Orientalizing 700–600 B.C.

Archaic 600–480 B.C.

Classical 480–323 B.C.

Hellenistic 323–30 B.C.

Etruscan 750–100 B.C.

Roman

Period of the Kings, 753–510 B.C.

Roman Republic, 509–27 B.C.

Roman Empire, 27 B.C.–A.D. 400

ABBREVIATIONS

acc.	accession number
cm	centimeter/-s
GRI	Getty Research Institute
H	height
inv.	inventory number
JPGM	The J. Paul Getty Museum, Los Angeles
L	length
neg.	negative number
n.	note
no.	number
pl./pls.	plate/-s
W	width

CONCORDANCE OF GREEK AND ROMAN DIVINITIES

Greek	Roman
Aphrodite	Venus
Ares	Mars
Artemis	Diana
Asclepius	Aesculapius
Athena	Minerva
Demeter	Ceres
Dionysus	Bacchus
Eris	Discordia
Hades	Pluto
Hecate	Trivia
Hephaestus	Vulcan
Hera	Juno
Heracles	Hercules
Hermes	Mercury
Hestia	Vesta
Poseidon	Neptune
Tyche	Fortuna
Zeus	Jupiter

The idea and impetus for this book came from Kurt Hauser, who developed a fascination for the often-overlooked statuettes of household gods and the personal story they reveal about ancient daily life and belief. I am deeply grateful to Kurt for gifting me such a fun project and to my dear colleagues from the Getty Villa for their support and encouragement—Claire L. Lyons, Kenneth D. S. Lapatin, Mary Louise Hart, Jens Daehner, David Saunders, Niki Stellings-Hertzberg, Paige-Marie Ketner, and Aurora Raimondi Cominesi.

The book was written in London and Oxford. The University of London Early Career Seminar organized by Victoria Gyóri and Frances Foster and the London Roman Art Seminar organized by Will Wootton allowed me to present work in progress in friendly environments and receive valuable comments. Dirk Booms welcomed me to the British Museum. Georgy Kantor provided me with a new academic home at St. John's College, Oxford, where the students have been a delight and inspiration. My new colleagues in Antiquities at the Ashmolean Museum made me feel part of the department from day one, and I am indebted to them for their warmth and generosity with time, advice, and ideas: Susan Walker, Paul Collins, Eleanor Standley, Liam McNamara, Anja Ulbrich, Alison Roberts, Helen Hovey, Ilaria Perzia, Claire Burton, Dana Macmillan, Senta German, and Paul Roberts.

I am immensely grateful to my patient and experienced editor, Benedicte Gilman, who deftly improved the text. My thanks also to the publisher at Getty Publications, Kara Kirk; to production coordinator Elizabeth Chapin Kahn; to Lindsay Jones for sourcing images; to Tahnee L. Cracchiola and Rebecca Truszkowski for their stunning photography; and to Kurt Hauser for his beautiful design.

The final months of writing tested the patience of family and friends. Special thanks to Libby Penn, Emma Libonati, Beth Munro, Mantha Zarmakoupi, Nick West, and Brooke Matin-Garbutt. Ed Bispham gave me the tools and confidence to pursue this field. Finally, to my extended household—Michael, Patricia, Nicholas, Irmie, Eva, the Boormans, and my husband Erie—I dedicate this book.

Alexandra Sofroniew
London, May 2015

If he had been asked today about the objects that best conveyed his sensibilities as a collector, J. Paul Getty would probably have singled out Roman imperial portraits and marble sculptures with distinguished pedigrees. Instinctively he gravitated toward objects with stories that palpably brought antiquity to life. Yet his first purchase of classical art, in 1939, was not a grand piece, but rather a terracotta relief of a woman reclining sensuously on a divan attended by two cupids. Graceful female figures veiled in supple folds of drapery had been in vogue among collectors since 1870, when the first of many thousand such figures were unearthed near the site of Tanagra in central Greece. Getty succumbed to their charms and selectively added small-scale works to his growing collection—Aphrodite leaning seminude against a column and a bronze effigy of a stern Tinia, the Etruscan Jupiter. Counseling him to acquire an exceptional fourth-century-B.C. bronze of the hero Phrixos holding the head of a ram with golden fleece, Getty's advisor, Louvre curator Jean Charbonneaux, spoke of its place at a point in history when aesthetics turned from the ideal toward the actual (J. P. Getty, *The Joys of Collecting*, 1965, p. 20).

The sense of tangible intimacy that can imbue a diminutive figurine with the spirit of its subject has held great appeal from antiquity to the present. Some, like the Phrixos or a petite Aphrodite carved from rock crystal, echo famous life-size sculptures by named artists. In the hands of master metalworkers and coroplasts, clay, bronze, and silver gave wide latitude for expressive modeling and innovation. Emerging from artists' molds was an endless variety of reduced-scale figures that could be at once ornamental, functional, and—as is evident from the places where they were later found—sacred.

In *Household Gods*, Alexandra Sofroniew considers small works of art as objects of reverence. Votive statuettes represent a significant portion of the Getty Museum's antiquities collection. Whether precious or humble, finely crafted or mass-produced, most such sculptures were used to solicit or express gratitude for divine favors. Statuettes of every sort have been found in sanctuary deposits, tombs, and artisans' quarters, and they are a rich source of information about ancient cult practices. In the fourth century B.C., the impulse toward realism coincided with an increasing emphasis on individual

religion, introducing a new cast of characters—dancers and musicians, actors, nurses tending children, animals—who turn up as tokens displayed and donated by the faithful. As certain gods gained in popularity, their likenesses were believed to ensure fertility, success in commerce and competition, and a safe journey to the afterlife. Portraits of regular men and women sacrificing or praying stood in for the person making a vow, suggesting that earnest acts of devotion could be just as meaningful as the material value of the gift itself. To judge from the number and diversity of dedications, which included rare materials of great worth as well as modest artifacts, both quality and quantity mattered to the gods.

Like the familiar icons that hang in contemporary chapels the world over, statuettes and figured plaques occupied a similarly important place in ancient homes. Though archaeological evidence for domestic rituals in Greece is scant, ancient authors describe how family members poured libations or offered food at altars and statues set up near the threshold, hearth, or on recessed shelves. Excavations in the residential quarters of Pompeii and other towns buried by Mt. Vesuvius have brought to light some five hundred *lararia*, which could take the form of a painted niche or a temple-shaped cupboard containing the *Lares*, ancestral deities usually accom-panied by an eclectic group of figurines. Some scholars speculate that affluent Romans had more sentimental than spiritual motives for building shrines filled with an array of Olympian gods and goddesses. Throughout the Mediterranean, however, it seems clear that the practice of assembling a personal pantheon as the focus for familial and civic piety was widespread and deeply felt.

During her time at the Getty, Alexandra Sofroniew organized exhibitions that presented compelling objects from ancient Sicilian sanctuaries and residences, showing how myths and images combined to guide the essential aspects of daily life—health, prosperity, and good fortune. Turning her attention to the notable collection of small-scale works of art at the Getty Villa, she here surveys religious devotion in the private sphere, bringing us a step closer to perceiving how visual imagery worked as an intermediary between the human and the divine.

Claire L. Lyons
Curator of Antiquities

1 COMMUNICATING WITH THE DIVINE

Let us begin from the Muses, who by singing for their father Zeus give pleasure to his great mind within Olympus, telling of what is and what will be and what was before.

—Hes. *Theog.* 36–38

Ancient Greek and Roman authors called upon the Muses to inspire their writing. Daughters of Zeus, the ruler of the Gods, and of the Titan Mnemosyne (Memory) and conceived on nine consecutive nights, each of the nine Muses held sway over a particular area of creative endeavor. Calliope is the Muse of epic poetry, Thalia and Melpomene of comic and tragic theater, Erato and Stesichore of song and dance (fig. 1). Clio, the Muse of history, is perhaps the most relevant for this text. The Muses were beautiful, graceful, and alluring goddesses through whose patronage the arts were elevated beyond mere leisure activities. Poems, songs, and theatrical performances were guided by and created in honor of the gods.

Indeed, every part of the ancient world was touched by the divine. The traditional pantheon of deities oversaw

Figure 1
Detail of wall-painting with a Muse. Roman, A.D. 1–75. Plaster and pigment. JPGM, acc. 70.AG.92.

2 all aspects of human affairs, from marriage and childbirth to illness and death, as well as success in athletic competitions and in the law-courts. Both the Greeks and the Romans personified as goddesses abstract concepts such as *Eris* (strife), *Virtus* (virtue), and *Tyche/Fortuna* (good luck). From the moment of birth, the three Fates worked on the thread of your life, spinning it, measuring its length, and readying their shears to snip it when your allotted time was up. The natural landscape of springs, rivers, mountains, and groves was populated by nymphs and minor gods. Half-man, half-animal mythical creatures such as Centaurs and Satyrs roamed the countryside. And local heroes became semidivine after death, their memorialized tombs places of worship.

Ancient homes were filled with images of gods and heroes.[1] These images could carry a strong religious significance, but they also had a decorative function as beautiful works of art. Brightly colored paintings and patterned mosaics covered the walls and floors of opulent homes with scenes taken from mythology, depicting gods and goddesses interacting among themselves and with mortals. Similar scenes were painted and engraved on the terracotta and metal vessels used for eating and drinking. Furniture such as candelabra and the wooden couches used to

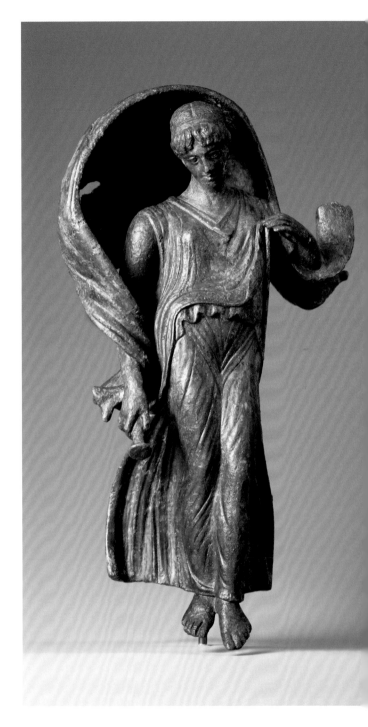

(fig. 3).[2] Divine images were carved into precious gems. Set into finger rings, brooches, or the pendants of necklaces, these gems were used as personal seals and worn as protective amulets (see fig. 42).

In this bustling polytheistic environment, religious behavior was embedded in daily life. Few actions and activities could have been regarded as purely secular. The gods were ascribed human emotions and could be jealous, petty, and vindictive as well as kind, generous, and caring. They could interfere at any time, so it was considered a matter of common sense to propitiate them. Someone might be skeptical of the stories of the characteristics and behavior of the gods or might worship completely different entities in a very different way, but the vast unknown fostered a general acceptance that the gods existed and could be for or against you.

Agalmata—Things That Are Pleasing to the Gods

The ancients conceived of their relationship with the gods as based on reciprocity, involving an exchange for mutual benefit.[3] Expressed in Latin by the phrase *do ut des* (I give so that you may give), the assumption was that if you approached the gods in

recline on for dining were decorated with bronze or ivory attachments and appliqués in the shape of divinities and mythical creatures. An elegant figurine from the first century B.C. depicts a goddess, probably Nyx, the personification of night, gently alighting with her mantle billowing behind her (fig. 2). In her right hand she holds a torch or a perfume jar from which she dispenses dreams; the statuette probably decorated a lamp stand. Even the simple and ubiquitous clay oil lamps that brightened rooms after dark could be embellished with the heads or figures of gods and goddesses

Figure 2
Statuette of a draped female figure, perhaps Nyx. Roman, first century B.C. Bronze, H: 25.4 cm (10 in.). JPGM, acc. 96.AB.38.

Figure 3
Oil lamp with figure of Mercury. Roman, first century A.D. Terracotta, L: 10 cm (4 in.). JPGM, acc. 83.AQ.377.27.

4

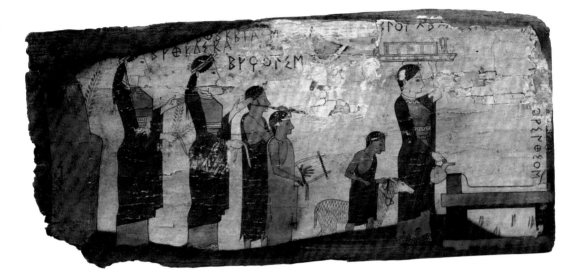

the correct way, asked for a favor, and fulfilled your end of the bargain, the gods would regard you favorably and grant your request. There were three main ways of communicating with the divine: through prayer, votive offering, and sacrifice. Prayer by itself was not sufficient; it had to be accompanied by a tangible gift or the promise of one to come. Gifts were given to honor the gods, to thank them for a favor already received, or in anticipation of a positive outcome. This reciprocal relationship was carefully maintained by individuals and families, but also by groups (such as the guild of bakers at Pompeii, who honored the hearth goddess Vesta) and by priests and priestesses on behalf of entire cities.

Animal sacrifices involved blood, fire, and meat. They were careful rituals performed according to prescribed methods.[4] First the sacrificial animal was selected. Cows were more expensive, sheep and goats the most common, and pigs relatively rare except for certain deities, such as Demeter. The animals were distinguished by sex; generally gods preferred male animals, and goddesses female ones. The chosen animal was led to the altar in a festive procession accompanied by musicians playing pipes or lyre and a youth carrying a basket containing the sacrificial knife (fig. 4). Grains and water were sprinkled over the altar while prayers were recited. Finally the victim's throat was cut and its blood spilled over the altar. The animal was

Figure 4
Pinax (painted votive tablet) showing sacrifice scene. Greek (from Corinth), 540–520 B.C. Wood, H: 15 cm (5 ⅞ in.). Athens, National Archaeological Museum, inv. A 16464.

Figure 5
Apollo and Artemis sacrificing at an altar; he holds out a *phiale* (offering dish) to pour a liquid offering on the altar, while she holds an *oinochoe* (jug) similar to the one on which the figures are depicted. Red-figured *oinochoe* attributed to the Rich-mond Painter. Greek (Attic), about 440 B.C. Terracotta, H to top of handle: 29 cm (11 ⅜ in.). JPGM, acc. 86.AE.236.

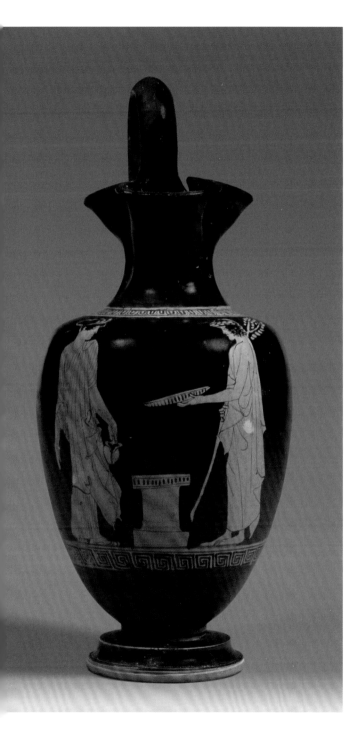

then butchered; traditionally the thigh bones were wrapped in fat and burned along with some of the innards to feed the gods, while the human participants divided up and feasted on the remaining meat. Conveniently, the gods preferred to receive the smoke from burning parts of the animal that humans did not care to consume.[5] The performance of a sacrifice was a key element of public festivals, and the subsequent shared meal bound the community together.

Animal sacrifices were also made privately at home, presided over by the head of the household. The ensuing meat feast attended by extended family and friends was a display of prosperity and enjoyment of the good life, sanctioned by the gods. Nonanimal sacrifices (libations) were performed by pouring wine or oil over altars in the home and at temples and shrines and by burning incense for the gods on decorated terracotta and metal incense stands. Libations were also made at tombs, both to placate the gods of the Underworld and to honor deceased ancestors. Depictions of men and women using an *oinochoe* (jug) and *phiale* (shallow dish for pouring a liquid offering) were popular decorations on pottery vessels and as stand-alone figurines used as votive dedications (fig. 5).

Our word votive comes from the Latin *votum* (vow). A votive offering

is physical proof of a pledge made to a divinity. The Greeks, however, also used the words *dora* (gifts) and *agalmata* (things that are pleasing to the gods) to describe these dedications. So what made a good gift for the gods? Hymns and dances could be *agalmata*, provided that they brought joy to their intended divine audience.[6] In general, however, gifts were physical items brought by the dedicator to a god's place of worship.

One main type of gift consisted of donating part of the result of one's labors. These items could be *aparche* (the first fruits) and consist of the first crops harvested, or *dekate* (literally, a tithe: tenth portion) of one's harvest or income. Both of these terms came to be interpreted more loosely over time, and people would commonly dedicate the tools and equipment of their profession, especially in thanks at retirement. A touching epigram (short poem) describes the offerings of a fisherman (fig. 6): "Piso the fisherman, weighed down by long toil and his right hand already shaky, gives to Hermes these his rods with the lines hanging from their tips, his oar that swam through the sea, his curved hooks whose points bite the fishes' throats, his net fringed with lead . . . " (*Greek Anth.* 6.6).[7]

Sculptures, plaques, and reliefs made in terracotta, wood, bronze, or marble were another important type

of offering. For the most part, these objects depicted a god or goddess, or individuals in the act of making a dedication or sacrifice.[8] They ranged from crude baked-clay tablets and wooden planklike forms with only minimal indication of human characteristics to magnificent life-size marble and bronze statues by some of the finest ancient artists. Brightly painted terracotta figurines were hugely popular and have survived by the tens of thousands in the archaeological record. We can trace their development from early Greek examples representing a goddess seated on a throne (fig. 7) to depictions of standing women swathed in drapery—a type that spread across the Mediterranean in the fourth and third centuries B.C. (fig. 8).[9] More tangible and longer-lasting than consumable offerings, statuettes and reliefs acted as *memna* (mementos) and were often accompanied by inscriptions naming the offerant, the intended deity, and the reason for the vow. Gift-giving was quite pragmatic, in a way similar to what we observed above with the division of meat between gods and humans after an animal sacrifice. People gave what they had, what they could afford. Some types of offerings acted as substitutes for more valuable items—such as terracotta animals in lieu of the real thing. Another epigram records such

Figure 6
Group of 125 votive fish, including herring, porgylike fish, probably a moth fish, and other undetermined species. Roman, second century A.D. Lead. JPGM, acc. 78.AI.365.

Figure 7
Statuette of an
enthroned goddess.
Greek (Boeotian),
600–575 B.C. Terracotta
and pigment, H: 17 cm
(6 ¾ in.). JPGM, ACC.
71.AD.132.

Figure 8
Figurine of a standing
woman, a so-called
Tanagra statuette.
Greek, 400–200 B.C.
Terracotta with traces
of polychromy, H:
29.1 cm (11 ½ in.). JPGM,
ACC. 56.AD.17.

10

a dedication to Demeter, goddess of agricultural fertility: "The two oxen are mine and they helped to grow the corn. Be kind, Demeter, and receive them, though they be of dough and not from the herd. Grant that my real oxen may live, and fill thou my fields with sheaves, returning me richest thanks" (*Greek Anth.* 6.40).

Indeed, some worshipers went as far as to promise in the text of their dedication a larger, fancier item should their circumstances improve, or they would remind the deity of their past gifts. These offerings became part of a longer conversation, a continual engagement between an individual and a deity that could stretch over a lifetime.

Public and Private Devotion

We know much about Greek and Roman religious practice thanks to descriptions in ancient literary sources, depictions on vases and reliefs, and the multitude of actual offerings (some with inscriptions) that have survived.[10] However, most of these practices were manifested in public. Sacrifices took place in the open air at altars positioned directly outside temple doors, so that the cult statue housed within could observe the ceremony. Votive offerings were left at sanctuaries (sacred enclosures) that could contain

multiple altars and temples as well as living quarters for worshipers and priests, theaters and stadia, shops, and natural features such as groves and pools (see fig. 51). Sanctuaries were crowded with dedications, erected in front of temples, fixed to wooden shelves, hung from trees, or stored inside treasuries, depending on their value and material.

It is virtually impossible to uncover the personal thoughts and feelings of the ancients as they performed these rituals. We must be cautious of clouding our interpretations of ancient belief, prayer, and direct communication with the divine with anachronisms based on the practices of subsequent Judeo-Christian religions. Piety was manifested through correct action rather than professed belief.[11] Moreover, while we have the writings of Greek and Roman philosophers and politicians on religious matters, these preserve the views of the educated and elite, rather than the average citizen, and still less the slave. Private domestic rituals such as burning scraps of food as offerings in the hearth or festooning the statuettes of divinities in a shrine with ribbons and garlands of fresh flowers leave few traces in the archaeological record. Moreover, closely associated with women and thus subject for a long time to scholarly gender bias, everyday worship in the home has been less well recorded and studied

than the grand public rituals that all aspects of civic life were predicated on, from athletic games and theatrical contests to political decision-making and going to war.

Nonetheless there is substantial archaeological evidence for household shrines from the Roman period found in situ. Most of our knowledge about Roman houses and domestic decoration comes from the Bay of Naples on the southwest coast of Italy. There, in A.D. 79, Mount Vesuvius erupted, burying the surrounding towns, farms, and luxury seaside villas.[12] Located south of the volcano, Pompeii first endured a steady rain of light pumice (volcanic rock) for around eighteen hours, which covered the city to a depth of more than 2.5 meters (8 feet) before it was finally overwhelmed by a series of pyroclastic flows—avalanches of hot gas and pumice—the following morning. Herculaneum, to the west of Mount Vesuvius, largely escaped the rain of pumice because of the wind direction, but due to its proximity to the volcano, it was hit much harder by the pyroclastic flows. Repeated surges of fine ash and volcanic rock moving at high speed covered the city to a depth of 20 meters (65 feet), almost ten times deeper than at Pompeii. These different effects of the eruption resulted in differences in the extraordinary levels of preservation

at the sites. At Herculaeneum, the intense heat of the first pyroclastic flows caused the remarkable conservation of wooden remains, including furniture and architectural features such as stairs and doorframes. In both places, homes have been uncovered largely as they were abandoned in A.D. 79, with finds of bread and fruit as testimonials to the last meals of the inhabitants (although the long duration of the eruption—two days—meant that many had time to flee, taking their valuables with them).

Recently, excavation at the Roman colony of Augusta Raurica in ancient Gaul (present-day Switzerland) has uncovered a large number of statuettes of household gods from a town of a size similar to Pompeii but in a very different part of the Roman Empire, further enhancing our picture of domestic worship.[13]

This book covers a period of around a thousand years, from the nascent Greek world around 700 B.C. to the beginnings of the Christian Roman Empire in A.D. 300, and an area spanning the Mediterranean from the Greek colonies of Syracuse and Taranto in Italy to the military outpost of Dura-Europos in Syria on the edges of the Roman world. After a general discussion of Greek and Roman domestic cult practices in chapters 2 and 3, chapter 4 examines

12 the way in which the statuettes placed in household shrines were inspired by some of the most famous statues of antiquity. The next three chapters turn to themes that are represented particularly frequently by the deities found in domestic contexts: love, wealth, and health. In chapter 8, we turn to examining cults that came from Egypt and the Near East. And, finally, chapter 9 explores the legacy of the pagan form of worship by considering Jewish and early Christian practices in the home as well as modern shrines in houses, businesses, and along roadsides.

Although most of the figurines reproduced in this book are in the collections of the J. Paul Getty Museum, the volume is not intended as a catalogue. Rather, I hope to give a sense of the original purpose and use of these objects. The majority of so-called votive offerings in museum collections have little or no provenance, and their exact function is difficult to pin down, especially because these items, made of wood, terracotta, bronze, and silver, were essentially multi-functional. The same statuettes were given as gifts to the gods at sanctuaries, buried in tombs, and used in the home for worship or just for decoration. Some objects may have performed more than one of these functions in their lifespan—displayed in a niche in the atrium (see chapter 3) of a house and then buried with a family member who favored it, or purchased at a sanctuary and taken home as a memento of the visit. These objects symbolize a desire to mitigate against the uncertainties of life and to celebrate its joys, from the birth of a healthy child to relief at recovery from illness or gratitude for the abundance of a harvest. The reasons for offering prayers to the gods expressed by the ancients may seem very familiar to us—common human hopes, dreams, and fears that remain a constant over the millennia that separate the modern world from that of Greece and Rome.

2 EARLY HOUSEHOLD WORSHIP IN GREECE

Zeus the Father gave her [Hestia] a high honor instead of marriage, and she has her place in the midst of the house and has the richest portion.

—Hom. *Hymn to Aphrodite* 29–32

In ancient Greece, worship inside the home centered on the goddess Hestia. The embodiment of the hearth—the fire essential for daily life—Hestia is described in the *Homeric Hymn to Aphrodite*.[14] Daughter of Cronus, the Titan ruler of the universe, and his sister Rhea, Hestia is the elder sister of Demeter, Hera, Hades, Poseidon, and Zeus. Because Cronus had been warned that he would be overthrown by one of his own sons, he promptly swallowed each child as it was born. Only with the final child was Rhea able to trick her husband-brother, handing him a stone and whisking the infant Zeus away to safety. Hidden until he reached manhood, Zeus then returned and forced Cronus to vomit up his siblings. As foretold, Zeus ultimately vanquished Cronus after a bitter fight between the gods and the Titans and took his father's place as

ruler of the universe. Hestia was both Cronus's eldest and youngest child—the first to be gulped down, she was the last to be spewed up.

Hestia is thus one of the highly revered older generation of gods. The Greeks conceived of twelve Olympian gods and goddesses who all lived on Mount Olympus in central Greece (except Hades, who ruled the Underworld). In addition to the Olympian gods, the Greeks also worshiped many other deities and deified heroes. Described in the *Homeric Hymn* as *potnia*, Hestia is courted by both Poseidon, ruler of the sea, and Apollo, god of prophecy and music.[15] But she is unmoved by the pleasures of the love goddess Aphrodite and rejects both of her suitors, stubbornly swearing by Zeus to remain a virgin forever. Respecting her oath, Zeus honors Hestia with a place "in the midst of the house" of the gods on Mount Olympus and of every Greek household, and with "the richest portion" of the animal sacrifices made by mortals to the divine, in other words the fat that she can use to keep the hearth aflame.

Hestia therefore represents the symbolic heart of the Greek home, associated with the major rites of passage: birth, marriage, and death. The hearth is also the physical location where new members of the household are welcomed.[16] Literary sources tell us about a ritual for newborn babies called the *amphidromia*.[17] Its exact details are uncertain, for different accounts vary, but on the fifth, seventh, or tenth day after the birth of a child the participants in the *amphidromia* run around the hearth carrying the infant (or run around the infant lying next to the fire), signifying that they judge the child worthy of acceptance into the family. The participants might be the midwife, the father, or, most likely, the women of the household in general. A celebratory feast followed, including gifts of octopus and squid from relatives. This may also have been the occasion at which the child was named.

The ancient Greek wedding lasted several days, involving the ritual bathing and adornment of the bride and groom, feasting, and a large public procession in the evening accompanying the bride to the residence of her new husband.[18] Lit by torches and accompanied by music and dancing, this procession was the focal point of the wedding, symbolizing the transition of the bride from girl to wife. On arrival at the groom's house, the couple was received by his mother. As part of the formal introduction of the bride into the groom's household, she was led straight to the hearth of her new home. There the couple knelt and were showered with symbols of prosperity

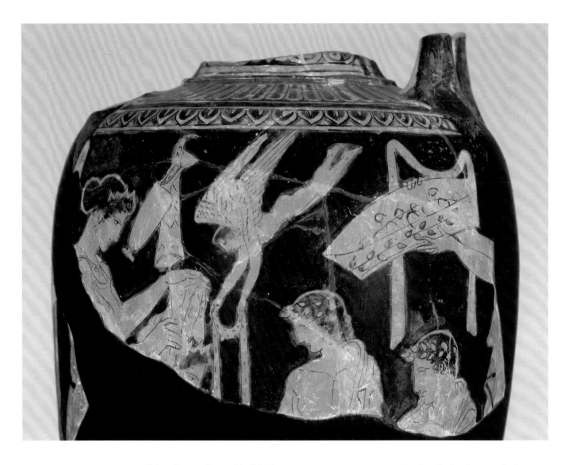

Figure 9
Bridal scene on a frag-
mentary red-figured
loutrophoros (vessel for
the ritual bath of the
bride). Greek (Attic),
attributed to the Phiale
Painter, 430–425 B.C.
Terracotta, extant
H: 18 cm (7 ⅛ in.).
Boston, Museum of
Fine Arts, inv. 10.223.

and fertility such as dried fruits, nuts, and coins in a ritual called the *katachysmata*.[19] A fragmentary *loutrophoros*, a type of vessel traditionally used to collect the water for the bride's prenuptial bath, is decorated with a scene showing the kneeling groom facing his new wife, who is being unveiled (a ceremony called *anakalypteria*), while the winged love god Eros hovers overhead, holding a garland (fig. 9). Above the groom, a person holds out a basket filled with the items of the *katachysmata*, ready to shower them over the couple. Hanging

vases and garlands further mark the scene as being set inside the home. Newly acquired slaves were similarly said to have been incorporated into a household by being led to its hearth.

As the personification of the hearth itself (the word *hestia* refers both to the physical fireplace or brazier and to the goddess), and generally rooted to her place at the center of the home, Hestia is rarely represented in Greek art.[20] Portrayed as a richly robed young woman but otherwise lacking in specific attributes like Athena's helmet or Zeus's

18 thunderbolt, Hestia can be difficult to spot in vase-paintings unless her name has been inscribed to identify her.[21] The earliest representations of Hestia that we can recognize appear on Athenian pottery in the black-figure style. On a *dinos* (bowl for mixing wine and water) in the British Museum dating to the early sixth century B.C., Hestia stands next to Artemis. The Greek letters of her name are scratched above her head, but she is otherwise indistinguishable among the cohort of goddesses (fig. 10). Here Hestia forms part of a procession of the gods celebrating the wedding of the sea nymph Thetis to the mortal Peleus, the future parents of the hero of the Trojan War, Achilles.

Heavy with foreboding, the depiction of the mythical wedding of Peleus and Thetis (in particular, the procession to the house of the groom, the focal point of the festivities) was popular with Greek vase-painters. Their customers would have been well aware of the story of which this happy scene was just a snapshot—the calm before the storm. Eris, the goddess of strife, was not invited to the wedding. Her devious revenge was to throw into the ceremony a golden apple marked "to the fairest," prompting a competition between the jealous goddesses Athena, Hera, and Aphrodite. They asked the Trojan prince Paris to judge their competition. Aphrodite secretly offered

Figure 10
Detail of a black-figured *dinos* (wine-mixing bowl) with Hestia in a wedding procession of deities arriving at the house of Peleus. Greek (Attic), signed by Sophilos as painter, about 580 B.C. Terracotta. London, The British Museum, inv. 1971,1101.1.

Figure 11
Hestia holding a scepter and a fruit on a *pyxis* (small lidded box) showing a wedding procession. Greek (Attic), attributed to the Splanchnopt Painter, 470–450 B.C. Terracotta, H: 7.6 cm (3 in.). London, The British Museum, inv. 1894,7-19.1.

him the beautiful Helen, queen of King Menelaus of Sparta, if Paris would choose Aphrodite. He did, and his subsequent abduction of Helen sparked the ten-year Trojan War.

Another famous example of the same scene, with Hestia in the procession of gods celebrating Thetis's wedding, again identifies the goddess by name. The so-called François Vase, named for its discoverer, Alessandro François, was uncovered around 1845 in Chiusi in central Italy, the area inhabited by the Etruscans in antiquity.[22] Originally made in Athens in the early sixth century B.C. and signed by both the potter and the painter ("Ergotimos made me; Kleitias painted me"), the François *krater*

(wine-mixing bowl) is decorated in lively black-figure with rows of different mythical scenes, all helpfully labeled with the names of the protagonists. Along with other images related to the Trojan War, a large middle band of decoration shows a joyous parade of pairs of deities, some in chariots, advancing toward the house of Peleus, who stands outside before an altar to greet his guests. Hestia walks alongside her sister Demeter, another matronly goddess associated with fertility.

These depictions of Thetis and Peleus mirror those of everyday Athenian couples taking part in the rites of marriage. On a *pyxis* (a small, lidded box often used by women to

20 store jewelry), a groom leads his bride home, clasping her wrist in a gesture that symbolized marriage.[23] Standing next to a flaming altar, is a goddess that is most likely Hestia. She holds a scepter and a fruit—perhaps a pomegranate or an egg, both associated with fertility (fig. 11).[24] The altar likely represents the hearth, with the newlywed couple being welcomed into the household by the groom's mother, who waves a torch in each hand.

In a passage of advice on the optimal marital partner, Plato describes two families united in marriage as *syniousai hestiai* (joined hearths): "Neither to shun connection with a poor family, nor to pursue ardently connection with a rich one, but other things being equal, to prefer always an alliance with a family of moderate means. Such a course will benefit both the State and the united families" (Pl. *Laws* 6.773).[25]

The Rise of the *Polis*

Around the turn of first millennium B.C., mainland Greeks were migrating to the western coast of Asia Minor (present-day Turkey) and resettling the Aegean islands. The period has long been called a Dark Age by historians, for no written texts survive from this time. However, increased archaeological excavation, publication of finds in museums, and scholarly research have illuminated the era, revealing peoples on the move and networks of settlements engaging in trade and the production of sophisticated crafts. After the period of the Mycenaean palaces (about 1450–1200 B.C.), exemplified by the grand complex at Knossos on the island of Crete, the Greeks were living scattered in small communities. The *polis* (city-state), from which our word *politics* derives, became the fundamental structure of Greek life, arguably shaping a unique character.[26] Beneath the umbrella of a shared language and belief system and a common identification as Hellenes, different *poleis* had their own government, customs, and ethnic and cultural identities, with some claiming descent from the Dorian Greeks in the Peloponnese, others part of the Ionian Greeks of Asia Minor. Although largely independent, city-states formed alliances or fell under the control of one another and participated in trading networks. Within this enterprising *polis* environment, contacts were renewed with the empires of the Near East, leading to changes in artistic and architectural styles and new techniques in carving sculpture and decorating painted pottery. At the end of this Dark Age period, in the late eighth century B.C., the Greeks adopted the alphabet

from the Phoenicians (the traders from the Levant famed for their purple dye) and used it to write down Homer's great epic poems, the *Iliad* and the *Odyssey*.

By the time of our main focus—the sixth century B.C. onward—Greek religious practices were largely civic affairs, closely bound up with the observances of an individual's *polis*.[27] While the great sanctuaries of Zeus at Olympia and of Apollo at Delphi hosted panhellenic festivals—celebrations for all of the Greeks—most worship took place at temples in the home city or at shrines and sanctuaries on the outskirts. Cities had their own patron deities, who were expected to pay particular attention to the fate of that *polis*, such as by supporting it in military endeavors. These deities were venerated with a temple in a central location. Thus, Athena, goddess of war and wisdom, was the patron deity of Athens. Her temple, the Parthenon, stood on the Acropolis—the highest point of the city.

Divine patronship was rewarding not only for the *polis* but also for the gods, who benefited from the sacrifices and offerings dedicated by the citizen body. Athena competed for her position in Athens with Poseidon, god of the sea. As the legend went, both offered the city a gift: Poseidon a horse and a salt-water spring, Athena the olive tree—a much more popular source of food, liquid, and heat (through olive oil)—which won her the patronship. It was expected that the gods would be present or take up residence within a particular temple or *polis*, at least for part of the year.[28] Places could also have their own specific versions of a deity, with an extra epithet to mark a local significance, such as Zeus Olympus or Zeus Dodona.[29]

Among these civic deities that varied from *polis* to *polis*, Hestia occupied a central place in many cities as guardian of a public hearth.[30] Literary sources provide many references to a *prytaneion*, a building housing the immovable hearth of the city, although very few have actually been identified in archaeological remains, perhaps only at Athens, Delos, Olympia, Lato on Crete, and Morgantina in Sicily.[31] The *prytaneion* functioned like a city hall, housing a continually burning flame that was used as the source of fire for civic sacrifices and a place of initiation of young men into citizen life (just as the domestic hearth was the point of introduction into the home for new members of the household).[32] The close connection between fire, sacrifice, and the cooking and consumption of meat is highlighted by the inclusion of dining facilities within the *prytaneion*. Hearths have also been found inside temples and sanctuary buildings, and there were specific temples dedicated to Hestia.[33]

22 An inscription for a priestess of Hestia named Tullia from Ephesus in Asia Minor celebrates her faithful service in a temple of the goddess.[34] Tullia presumably acted as a caretaker for the temple and its sacred fire, performed sacrifices, and oversaw visitors, and she is credited with acting "eagerly and willingly" and providing "her wealth for every purpose," while Hestia is honored as the goddess "to [whom] Zeus the ruler has given the right to control the eternal flame for the city."

At the Hearth of the Home?

The evidence for civic *prytaneia* and temples to Hestia has led to the assumption that the domestic hearth was similarly intended to be an everlasting flame, always burning as a symbol of the household. Indeed, the presence of a specific goddess of the hearth might imply that it was a fixed central point in every home. The archaeological remains, however, reveal a surprisingly different picture. Although we must take into account the limitations of our evidence (few ancient Greek residential areas have been systematically excavated), fixed stone hearths are rarely found. Ancient Olynthus, a city in northern Greece, was destroyed in the mid-fourth century B.C. by Philip

of Macedon, father of Alexander the Great, during his conquest of Greece. As the city was not subsequently rebuilt or reoccupied, it has been preserved as it was left at that time, with thousands of artifacts in situ in houses and public buildings. Over a hundred houses have been excavated from the city, providing an invaluable source of information for ancient Greek domestic life.[35] Out of these, only a very small proportion had fixed, stone-built hearths.[36] Similarly, in Athens, only a handful of houses with fixed hearths have been excavated.[37]

While it was also the place of domestic cult, the hearth's main function was for heating and cooking. As houses grew from simple one- and two-room structures, a central hearth was no longer sufficient for heating. Instead, charcoal-burning portable braziers were used. The ancient Greek hearth was moveable, just as other rooms in the house had variable functions, save perhaps for a formal dining room where built-in stone couches were decked with throws and cushions for drinking and dining parties. Cooking a meal, done by slaves or the women of a poorer household, could have taken place in different areas of the house. As we see from Olynthus and other sites, from the fifth century onward many ancient Greek houses were constructed on a courtyard model with rooms around a

central open space providing light, air, and an area for female members of the household to work without being seen in public. While there is some evidence for rooms designated as kitchens (often positioned next to bathrooms due to the practicalities of providing and heating water in a layout that we will meet again in Roman houses), it seems that food preparation and consumption could take place in the courtyard or adjoining rooms, depending on inclination and the weather. Moreover, because of the difficulties of storing cooked food, small amounts may have been made at different times of the day for various members of the household to eat separately; on an everyday basis there was little of the modern family meal around the dining room table that we might aspire to.[38] These casual meals would have contrasted with celebratory dinners held with extended family and friends on special occasions and with the lavish, formal public feasts that took place following civic sacrifices in the homes of the elite.[39]

The Greek *oikos* (household), from which we derive the English word *economics* (literally, household management), was considered the building block of the city-state. Encompassing more than the physical confines of a single house—commonly occupied by an extended family with slaves all living

under the same roof—the conception of the *oikos* also included friends and nonkin connected to the home.[40] Moreover, the *oikos* was an important source of production and income, a fundamental unit of the ancient economy. Surplus goods made at home by women, as well as agricultural crops grown by men, were sold in the *agora* (marketplace) or from storefronts incorporated into residential buildings.[41] Scenes on painted vases depict women at work, mainly spinning wool and weaving cloth. A large number of lively terracotta figurines has been recovered from the region of ancient Boeotia showing women kneading bread, preparing food, and tending domestic animals (fig. 12). The large-scale archaeological excavations at Olynthus have uncovered evidence for storing and processing agricultural surplus in the home, including activities such as grinding grain to make flour, baking, preserving fruits and vegetables, and even pressing olives and grapes in larger households.[42] Most houses had storage facilities, ranging from designated storerooms to individual *pithoi* (huge pottery vessels), to provide for the household during the year and gather food and textiles for sale.

Indeed, the other main deity connected with the household was Zeus *Ktesios* (of one's property), the god of the storeroom. The guardian of

24 the family's wealth and symbol of the prosperity of the *oikos*, Zeus *Ktesios*, like Hestia, was the personification of a physical object—a storage jar filled with foodstuffs (also sometimes worshiped in the form of a snake).[43]

Private devotion inside the home down to the end of the Hellenistic period is difficult to pin down, for the Greeks did not have a fixed category of "household gods." Instead, families venerated their ancestral gods, divinities whose worship was passed down through the generations and could vary according to the traditions of each *oikos*.[44] Alongside Hestia and Zeus *Ktesios*, Zeus *Herkeios* (of the courtyard), and Apollo were commonly worshiped, with images of Hecate and Hermes guarding the boundaries of the house (as Priapus would in the Roman period). There is little archaeological evidence for fixed stone altars in Greek homes. Animal sacrifices and offerings such as burning incense, pouring libations, and leaving fruits and garlands would have taken place at portable altars on days of celebration for the household. Much family religious practice took place outside the home—terracotta and stone reliefs show parents and their children visiting sanctuaries together to offer votive gifts and sacrifices to the gods (see fig. 50).

We have begun this book with Hestia. According to an ancient Greek proverb, "to begin with Hestia" was to make a good start. As the source of life through warmth and the heat used for cooking and for purification, the household fire was, not surprisingly, seen as divine, and Hestia was associated with the regeneration of the *oikos* for each successive generation. Now we turn to her Roman counterpart, Vesta.

Figure 12
Statuette of a woman feeding a hen and her chicks. Greek (Boeotian), 500–475 B.C. Terracotta and pigment, H: 13 cm (5 ⅛ in.). JPGM, acc. 96.AD.101.

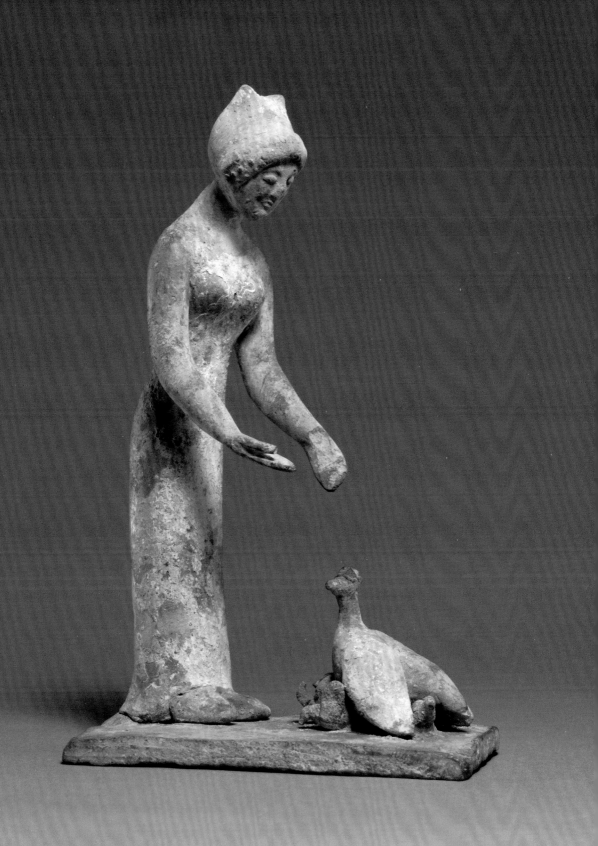

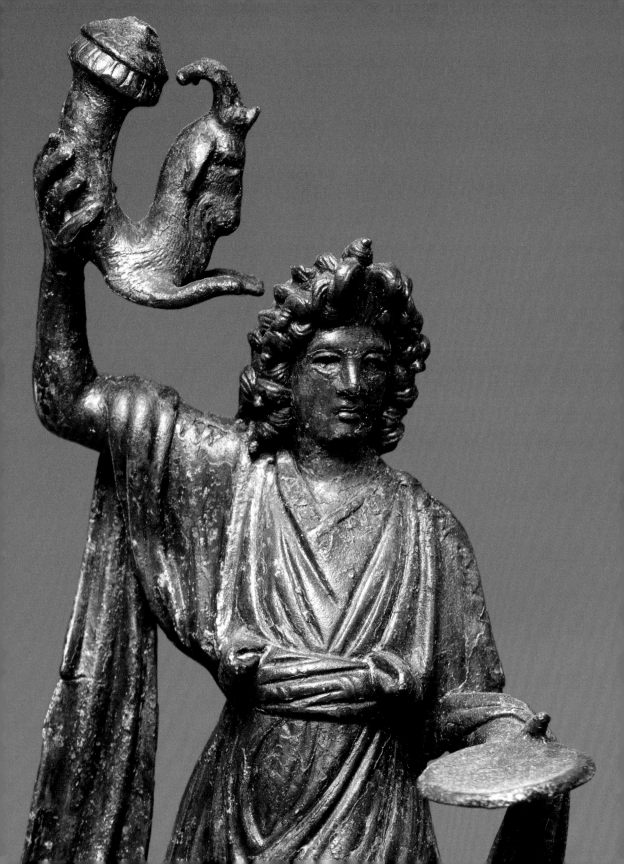

POWER AND PROTECTION: THE ROMAN *LARES, GENII, AND PENATES*

What is there more holy, what is there more carefully fenced round with every description of religious respect, than the house of every individual citizen? Here are his altars, here are his hearths, here are his household gods, here all his sacred rites, all his religious ceremonies are preserved.

—Cic. *House* 41

In 57 B.C., the Roman senator and lawyer Cicero (106–43 B.C.) returned to Rome from exile in Macedonia. He had been banished a little over a year before under a senatorial decree orchestrated by his adversary, the violent demagogue Clodius (about 92–52 B.C.). On opposing sides of the political divide, they were also embroiled in a deeply personal and bitter feud that involved Clodius's sister, Clodia, whose name Cicero had called into disrepute (even going so far as to hint at incest between the siblings). While Cicero was in exile, Clodius, to reinforce his revenge, had succeeded in passing a decree that specifically ordered the confiscation of Cicero's property. On his return, Cicero found that his home on the Palatine Hill had been destroyed, and, to add insult to injury, that Clodius had arranged for the land to be sanctified and a shrine to the goddess Liberty to be constructed on the site.[45]

28 Cicero took his case to the senate, where it was referred to the college of priests that dealt with matters of public religion. Cicero gave an impassioned speech, arguing that Clodius acted immorally and against the wishes of the gods in seizing his property. Cataloguing his own tireless devotion to the state and faultless observance of religious practice, Cicero was successful; he was allowed to remove the shrine and rebuild his home.

The house of a Roman senator such as Cicero was vital to the perception of his social standing. It acted as a workplace and the public front of the head of the household rather than as a private place of refuge as we may see it today.[46] The typical layout of an elite Roman house consisted of a narrow *fauces* (entryway) leading into a grand hall called the *atrium*, which was open to the sky (fig. 13).[47] Here the head of the household would receive his clients, a range of hangers-on, dependents, and supporters seeking his advice, patronage, or financial assistance. Every morning long lines of people could be found waiting to gain entry outside the houses of the most powerful men in Rome. Later in the day, more important guests might be invited to dine in one of several dining rooms or, for a more secluded meeting, in one of the small *cubicula* (rooms commonly furnished

with couches or beds) off the atrium. Although nominally bedrooms, these small, dark spaces were multifunctional and could be used also for business or relaxation. Courtyards and peristyles enclosing gardens decorated with statues, fountains, and pools brought light and air into the home and created a pleasant space for strolling in thought or conversation. Finally, narrow corridors led to living and work areas for slaves, such as the kitchen. Second stories (some are preserved at Herculaneum and Pompeii) provided more living space, or were converted into apartments for extended family or for rental income. Rooms on the ground floor on either side of the *fauces* facing the street were typically used as shops that were sometimes connected by a door to the house behind them.

In addition to functioning as a public manifestation of an individual's wealth and prestige, the Roman house was also at the heart of private devotion, for all levels of society. In his speech to the college of priests, Cicero emphasizes the religious importance of the home: it not only contains the physical space for worship and the paraphernalia used for that, but it also holds the memory and tradition of all the rituals and ceremonies performed by the household. As we have seen in the previous chapter, the hearth was the central element of domestic worship for the Greeks. Here, Cicero

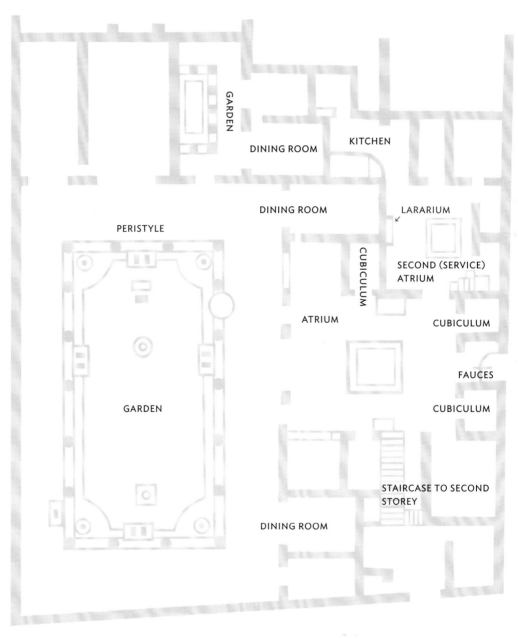

GARDEN

KITCHEN

DINING ROOM

DINING ROOM

LARARIUM

PERISTYLE

CUBICULUM

SECOND (SERVICE)
ATRIUM

ATRIUM

CUBICULUM

FAUCES

GARDEN

CUBICULUM

STAIRCASE TO SECOND
STOREY

DINING ROOM

Figure 13
Plan of an atrium
house. House of the
Vettii, Pompeii.

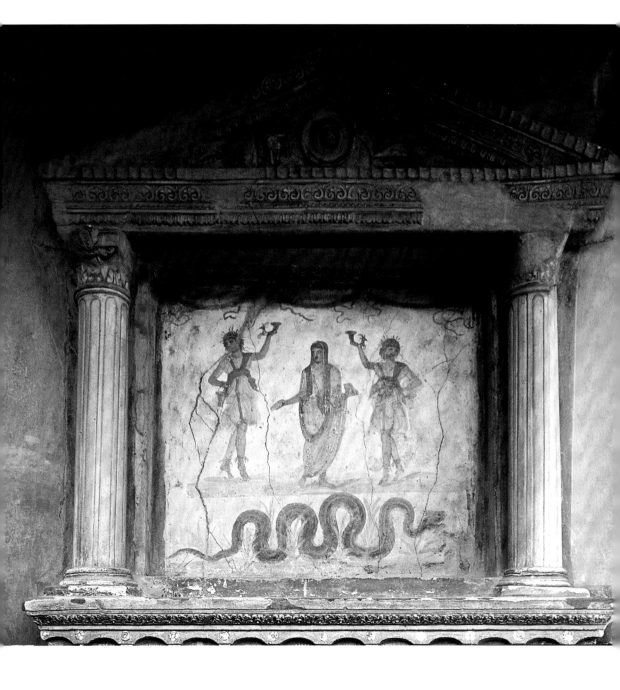

also mentions the hearth (*foci*, literally, fires) and altars as essential elements of household cult. However, his list contains an item that is particularly Roman—the *Penates* (household gods).

In the Roman period, domestic worship centered around three main types of divinity—the *Penates* (from *penus*, larder), the *Genius* (the spirit of the master of the household, and later the emperor himself), and the *Lares* (spirits of the familial ancestors and their territory). Statuettes of these divinities were kept in a special location, a shrine, within the home and were venerated with prayers, libations, and sacrifices. A few elite houses had designated rooms, *sacella*, that were equipped for worship, like a private chapel, with a permanent altar, benches, and appropriate wall-paintings.

We have a considerable amount of archaeological evidence from Pompeii, Herculaneum, Ostia, and other sites in Italy for what these household shrines looked like.[48] Our extant examples are very standardized, with certain key features. At a basic level, all that was required for domestic cult was an altar on which to make offerings and some sort of image of the gods. These could both be entirely portable—a small stone, terracotta, or marble altar and wooden, terracotta, or metal figurines. However, many houses had one or

more purpose-built shrines to house the statuettes of the gods; a permanent stone altar could be set in front of these shrines. These purpose-built shrines take three main forms—a simple curved or rectangular niche built into a wall of the house, an *aedicula* (niche or stand-alone cupboard decorated to resemble a miniature temple), or a wall-painting.[49]

Set into the wall around chest height, niches and *aediculae* are generally brightly painted, but a wall-painting of the gods with an altar placed in front of it could function alone as a household shrine. The floor of the niche often projects out in front as a shelf to provide a larger space for offerings (and lamps), and a step could be added at the back to raise the figurines displayed inside. The *aedicula* is a fancier niche where extra stucco has been used to build a pediment above and columns to the side of the recess to frame the images inside (fig. 14). This miniature temple can also be a stand-alone entity supported on a podium of some sort rather than being built into the wall.[50] A remarkable wooden example is preserved from a house in Herculaneum (fig. 15).[51] The shrine, in the form of a temple with Corinthian columns, contained a bronze statuette of Hercules and a marble figurine of a goddess (perhaps Venus); it was set onto a wooden cupboard holding terracotta and glass vessels.

Figure 14
Lararium (household shrine) from the House of the Vettii (VI.15.1) in Pompeii. Its location in that house is shown on the plan in figure 13.

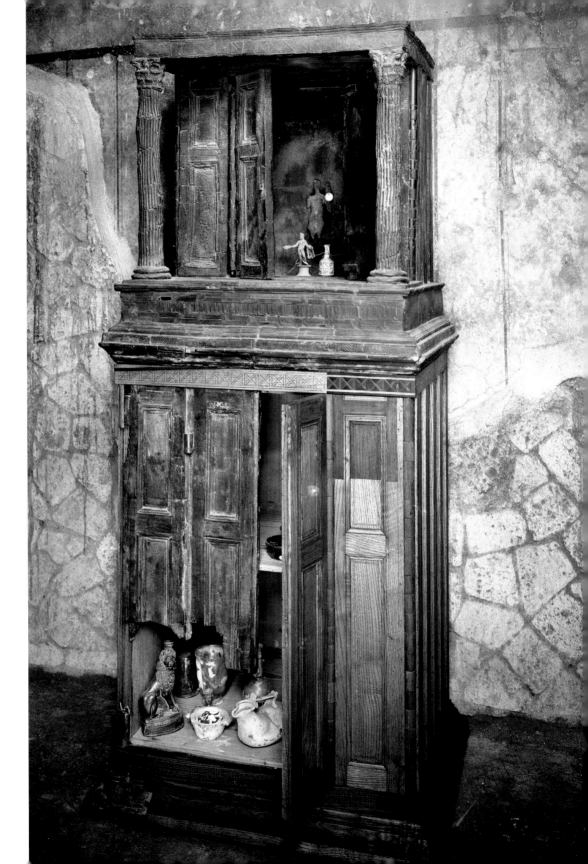

The wonderfully vivid paintings that form part of Roman household shrines give us a rich picture of an intimate part of family life.[52] The main components are strikingly consistent: the twin *Lares*, in mirror-image poses, flanking a central veiled figure (generally the *Genius*) pouring a libation onto a flaming altar, surrounded by Vesta and other deities or occasionally a procession with musicians for an animal sacrifice. Garlands or plants often adorn the scene. Below this main scene, a second painting shows an altar with offerings on it such as pine cones or eggs (both symbols of fertility), and one or more snakes approaching it. Both the Greeks and the Romans regarded snakes as guardians of houses and altars.

The *Lares*

The *Lares* were protective spirits generally represented as twin young men. Their origin is somewhat of a mystery to us, as it was for the Romans thmemselves. Literary sources record *Lares* with several different epithets, designating various areas of oversight. In addition to the *Lares familiares* ("of the family"—the main domestic version), *compitales*, and *praestites* (guardians of crossroads and of the city, respectively), we also know of *Lares agrestes*

(protecting the fields) and *Lares viales* and *Lares permarini*, who watched over travelers by road and by sea, respectively. The *Lares familiares* were by far the most common, an essential part of every household shrine.

The poet Ovid (43 B.C.–A.D. 17) discusses the parentage of the *Lares* in the *Fasti*, his description and explanation for the religious festivals of the Roman calendar. He relates that the twins were born to a nymph named Lara—nicknamed Lala, because she spoke too much—and the messenger god Mercury (Ov. *Fast.* 2.599–616). Ovid emphasizes their protective nature, comparing the *Lares praestites* to faithful dogs that literally stand before the city as guardians:

Both guard the house,
both are faithful to their master,
cross-roads are dear to the god, cross-roads
 are dear to dogs,
the Lar and Diana's pack give chase to thieves,
and wakeful are the Lares, and wakeful too
 are dogs.[53]

The *Lares* were also worshiped at a public festival called the *Compitalia*.[54] Traditionally a rural family festival observed at cross-road shrines marking the boundaries of a household's estate, the *Compitalia* was revived under Emperor Augustus (ruled 27 B.C.–A.D.14) and was also celebrated at communal stone altars built on street corners in

Figure 15
Wooden shrine from the House of the Wooden Shrine in Herculaneum. Soprintendenza Archeologica di Pompeii, neg. 309.

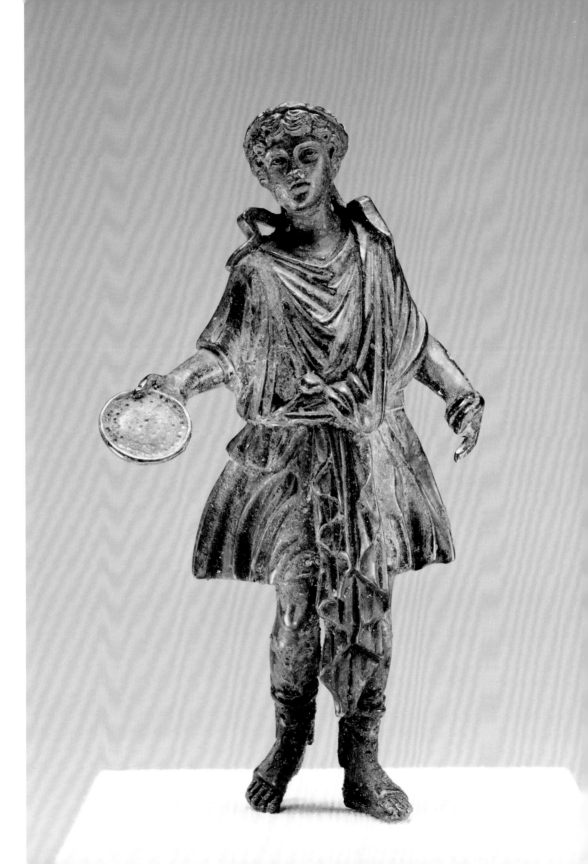

towns and cities. Taking place at the end of December or early January, the *Compitalia* became a neighborhood festival to foster local cohesion. In addition to animal sacrifices and accompanying meals, figures of wool were hung from the neighborhood altars to represent each member of the local community—male and female woollen puppets for free men and women and woollen balls for slaves. Stone altars used for the *Compitalia* have been found depicting the twin *Lares* and magistrates making offerings.[55]

Thousands of small bronze figurines in the highly distinctive form of the *Lares* have survived from antiquity. Mostly 10–30 cm high (4–12 in.), they have been recovered from sites across the Roman Empire, from Spain to Britain to Gaul, as well as Italy.[56] Although there are small differences in the styles of the figurines and the skill of their execution, in general they are remarkably consistent. The *Lar* is depicted as a youth with curly hair, wearing a short tunic, a mantle tied around his waist, and high open-toed boots. Occasionally he is shown holding a cornucopia or a *patera* (offering dish), with the cloak around his waist forming zig-zags of cloth hanging down in front, and the ends of the wreath tied around his head and falling onto his shoulders (fig. 16). More commonly, the *Lar* is represented on tiptoes, holding aloft

a *rhyton* (drinking horn), with a *patera* or *situla* (bucket) in his other hand (see fig. 17a). With his tunic swirling out around him from the vigor of his movement, this type is known as a *Dancing Lar*. This is the type we see in wall-paintings, which also reveal the bright colors of their clothing. On the shrine from the House of the Vettii (see fig. 14), the *Lares* hold drinking horns in the shapes of stags and small metal *situlae*. Their red cloaks are tied around their waists, and their tunics are decorated with a red stripe running down the front.[57] Other examples show the *Lares* with yellow, green, blue, or striped tunics.[58]

The *rhyton* originated in the Near East, made from precious metals, often in the form of the foreparts of an animal, usually a stag, panther, bull, or ram. Adopted by the Greeks, *rhyta* were used during the *symposium* (an elite male drinking party). Pouring wine had a strong religious significance. In some wall-paintings we can still see dark streams of liquid as the *Lares* pour wine in a wide arc from their *rhyta* into the buckets they hold in their other hands.[59]

The fact that the *Lares* hold drinking horns and wear soft animal-skin boots laced up the leg—a typically south Italian style of footwear—connects them with the exuberant, drunken worship of the wine god Dionysus (Roman

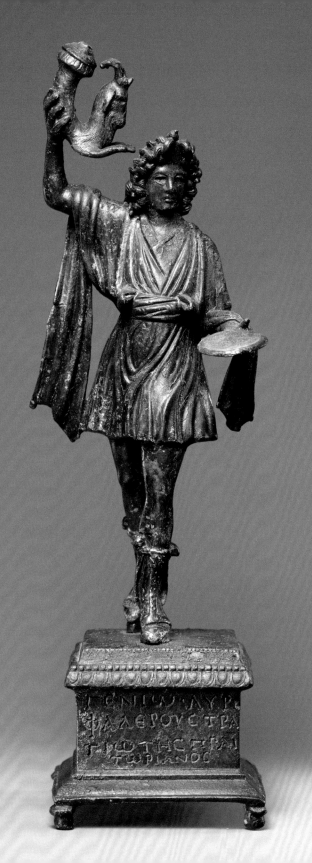

Bacchus) and with the Greek and Italic peoples of southern Italy, although they may also have roots in Etruscan customs. Whether they were in origin the spirits of a family's ancestors, or, more likely, agricultural divinities that came to represent and protect the land holdings of a household, the lively twin *Lares* were a joyful presence in the home.

The poet Tibullus (55/48–19 B.C.), a contemporary of the poet Horace (65–8 B.C.) in the late Republican period, imagines making an offering to the *Lares* for a fruitful harvest. Although the character in the poem has fallen on hard times, the elegy celebrates the simple rustic delights idealized by the Roman upper classes:

Ye too, my Lares, who watch over an estate, now poor

though thriving once, receive your gifts.

Then a slain heifer was peace-offering for uncounted bulls;

a lamb is now the humble victim for my narrow plot of ground.

A lamb shall fall for you, and round it the country youth

shall shout: "Huzza! Send us good crops and wine!"

(Tib. *El.* 1.19–24)

The *Genius* of Aurelius Valerius

At first glance, figure 17a is a fine example of the *Dancing Lar* type, holding high a goat's-head *rhyton* and with the ends of his knotted mantle streaming behind him. However, it is unusual for the original base to be preserved, and rarer still for that base to be inscribed (fig. 17b).[60] Most surprisingly, the text is a dedication, "To the *Genius* of Aurelius Valerius, praetorian soldier."

The *Genius* was the spirit of the living male head of the household, the *paterfamilias*.[61] It embodied his procreative power—the life force of the family— that would continue the family name. In particular, a man's *Genius* was venerated on his birthday and on his wedding day (many Roman men and women married multiple times due to divorce or the death of their spouse). We have some evidence for a female equivalent, the *Iuno*, which a woman would honor on her birthday. On wall-paintings and in

Figure 17a

Statuette of a *Lar*, the *Genius* of Aurelius Valerius. Roman, third century A.D. Bronze, H: 30.8 cm (12⅛ in.). JPGM, ACC. 96.AB.200.

Figure 17b

Latin and Greek inscription with Greek letters on the base of figure 17a: "To the *Genius* of Aur[elius] Valerius, praetorian soldier."

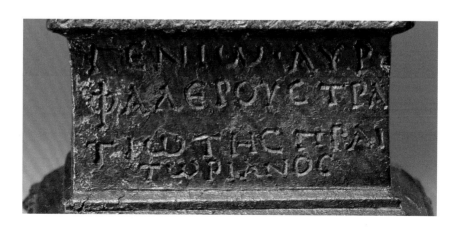

38 bronze figurines, the Genius is shown wearing a toga with a fold of the cloth pulled up over his head —Roman priests and priestesses covered their heads thus during public rituals—holding out a patera to make an offering. Sometimes he holds a cornucopia as well, or (in wall-paintings) he is accompanied by sacrificial attendants. On the shrine from the House of the Vettii (see fig. 14), the central figure of the *Genius* holds an incense box in his left hand (as does a bronze from Boscoreale, see fig. 21, far left figure). The snakes commonly depicted surrounding an altar in *lararia* may represent the *Genius*, or they may be a general symbol of protection.[62]

Under Augustus, the *Genius* of the emperor became the subject of widespread public veneration by individuals and communities, as safekeeping of the imperial family became synonymous with the protection of the Roman state at large. There could also be *Genii* of guilds, cities, and peoples, such as the *Genius populi romani* (the Genius of the Roman people).

The *Lar* in figure 17 was dedicated to the *Genius* of a soldier. Because the find context is lost, we do not know whether it stood in the *lararium* of Aurelius's home. Ovid poignantly uses the analogy of a soldier offering his weapons at a household shrine as a sign of preparing for a peaceful old age: "When the

soldier after years of service is no longer useful, he lays the arms he has borne before the antique *Lares*" (*Tr.* 4.21–22). Or perhaps Aurelius carried his *Lar* with him on campaign, inscribing it so as to mark his property and his standing, taking pride in his position as praetorian soldier—a force charged with protecting the emperor.

Vesta and the *Penates*

Like the Greek Hestia, Vesta was the Roman goddess of the hearth, but she was particularly closely associated with the city of Rome and played a public role as the guardian of the Roman state through the preservation of an eternal flame. Her unusual round temple in the Forum Romanum housed this fire and the *Penates* of the city—including the legendary Palladium, the wooden cult statue of Athena, said to have been brought from Troy by the ancestral founder of Rome, Aeneas (fig. 18).[63] Vesta's cult and the sacred fire were maintained by the Vestal Virgins, six young women from elite families whose chastity was sacrosanct (the punishment for losing their virginity was burial alive).[64] The cult of Vesta was thought to date back to the time of the kings of early Rome (753–510 B.C.), growing out of the private veneration of the

Figure 18
Wall-painting in the
House of Menander
in Pompeii (I.10.4),
showing the Trojan
princess Cassandra
clinging to the statue
of the Palladium.
A.D. 1–79. Plaster and
pigment.

king's hearth by the women of the royal household. Indeed, various Roman authors writing in the Republican and Imperial periods relate the story that the legendary king Servius Tullius (conventionally 578–535 B.C.) was born from a maidservant impregnated by a phallus that appeared from the hearth, and that he was thus the son of a *Lar*.[65] As we saw with Hestia, there was an ambiguity in Vesta's status of both virgin and procreative power—a model of a phallus was supposedly kept in her temple.

Vesta seems to have played a lesser role in private worship, although depictions of the goddess are found in domestic shrines. At Pompeii, she was the patron goddess of professional bakers, a flourishing trade in the city, through an obvious connection with ovens. In wall-paintings she is represented as an enthroned goddess, sometimes accompanied by a donkey, for those animals turned the mills that ground the bakers' flour.

The *Penates* came to refer generally to all the gods venerated at home, and the word could be used to mean the house itself. Most of the statuettes pictured in this book are thus *Penates*. Surviving assemblages reveal an eclectic mix of objects. At the House of the

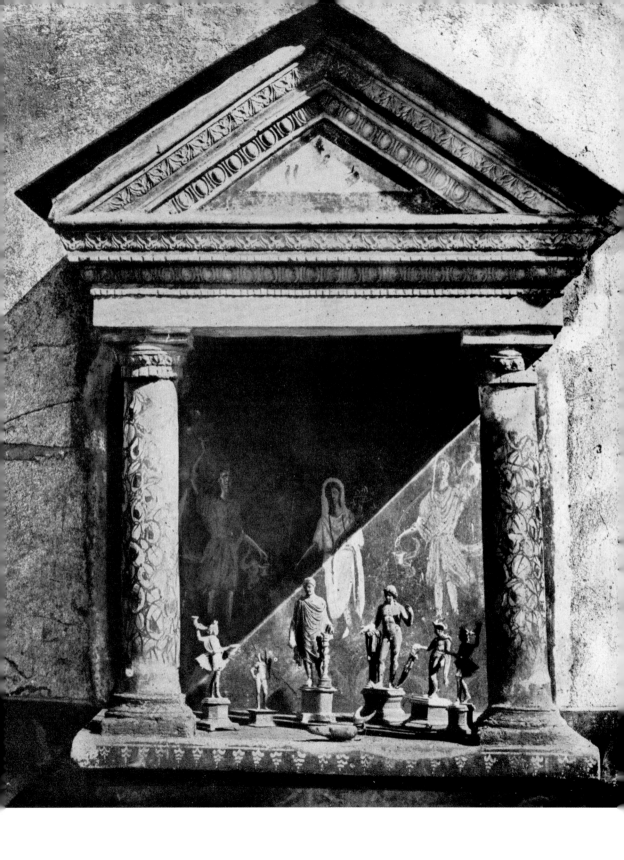

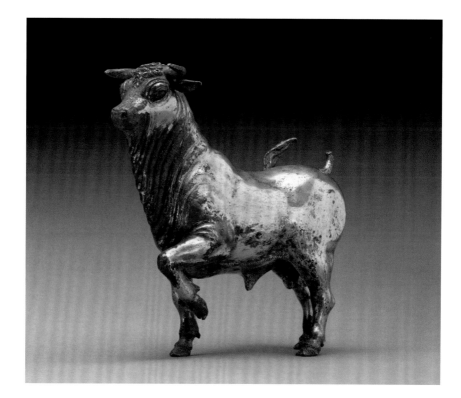

Red Walls in Pompeii, an *aedicula*-type shrine was found in the atrium (fig. 19). The wall-painting shows the *Lares* in cheery blue tunics with red mantles, flanking a central *Genius* holding a cornucopia. Inside the miniature temple stood six bronze statuettes: the two *Lares*; Aesculapius, god of medicine; Apollo, god of music and prophecy; the messenger god Mercury; and Hercules.[66] Another large dwelling at Pompeii, the House of the Upper Storey (Casa del Cenacolo), with a preserved second floor, contained three shrines: a painted niche in the *fauces*, one in the kitchen, and an *aedicula*-style niche in a space leading out to the garden. Preserved

in the latter is an unusual painting of Hercules making an offering at an altar with a pig observing him to the right. Inside the *aedicula* were found a bronze statuette of Mercury, a bronze statuette of a kneeling woman, a terracotta Minerva, a terracotta votive head, a small terracotta altar with traces of burning, a terracotta oil lamp, a dolphin amulet, and two coins.[67]

A gilt silver bull found at Pompeii would have stood in a domestic shrine as a symbol of Jupiter (fig. 20). A shrine could even contain two images of the same deity, such as a group of bronzes found near the kitchen of a villa at Boscoreale with enthroned and standing

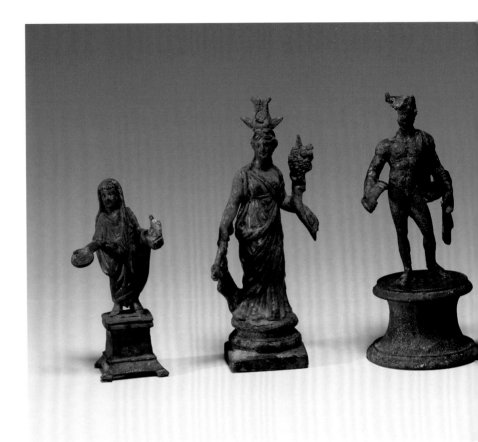

Figure 21
Seven bronze statu-
ettes found together
in a villa at Boscoreale,
Italy. Roman, first
century A.D. From left
to right: (1) *Genius*, H
with base: 8.6 cm (3⅜
in.), inv. 54.752; (2)
Isis-Fortuna, H with
base: 11.4 cm (4½ in.),
inv. 54.751; (3) Mercury,
H: 11.5 cm (4½ in.),
inv. 54.748; (4) seated
Jupiter, H with base:
8.6 cm (3⅜ in.), inv.
54.750; (5) Alexander
Helios, H: 9.1 cm (3⅝
in.), inv. 54.2290; (6)
standing Jupiter, H with
base: 10.5 cm (4⅛ in.),
inv. 54.749; (7) Isis-
Fortuna, H with base: 9
cm (3½ in.), inv. 57.747.
Baltimore, Walters Art
Museum.

versions of Jupiter and two figurines of
the Egyptian goddess Isis (fig. 21).[68]

The individual variety no doubt
results from personal preference, the
addition of meaningful objects from
time to time, and the wealth of the
family. Some of the figurines may be
"antiques," heirlooms passed down for
generations. Moreover, images made
in organic materials such as wood, wax,
or wool have not survived.[69] We might
imagine quainter homespun items
alongside, or instead of, precious silver
and bronze statuettes.

Daily Practices

Although archaeological evidence has
preserved the appearance of house-
hold shrines and very occasionally an
assemblage of *Penates* within them,
brief mentions in literary texts are our
main source of information on when, by
whom, and what offerings were made
in the Roman home.[70] Private devotion
was an everyday activity infrequently
discussed in the surviving ancient
texts. However, much can plausibly be
reconstructed. A Neoclassical painting

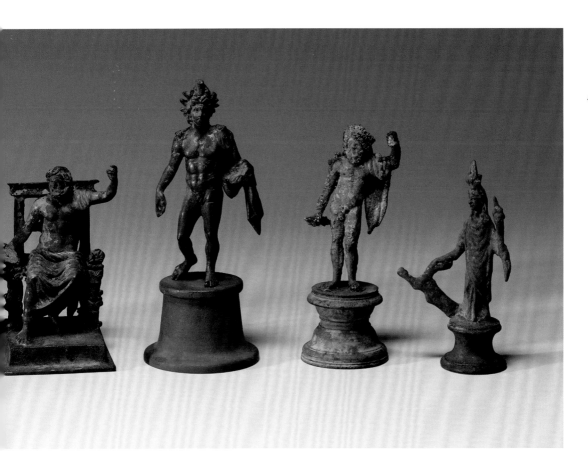

presents a charming imagined scene of ancient domestic observance (fig. 22). Two girls, one holding a basket of garlands, the other pouring a libation from a jug to a dish, stand in front of a number of shining bronze statuettes with a brazier in front.

Rites were nominally led by the head of the household acting on behalf of the family. Elite Romans such as Cicero commonly had more than one house—a political base in Rome and villas and farms in the countryside or in their hometowns—each of which would

have shrines to maintain. Writing in the second century B.C., the senator Cato (234–149 B.C.) tells us that the first stop an owner should make on a visit to one of his estates is to pay respects to his *Lares* (*Ag.* 2). But women no doubt sometimes took the lead or performed the rites by themselves. Children were honored at their household shrine with a special coming-of-age ceremony marking their transition to adulthood, and they also participated with their parents on a day-to-day basis, just as they acted as assistants in public cult.[71] Slaves were

44 included in the worship of the *Lares* and *Penates*, and shrines in dingier areas of the house may have been intended primarily for servants' use.

The household gods were venerated on the *kalends* (1st), *nones* (5th or 7th), and *ides* (13th or 15th) of each month and on birthdays and special occasions. They were also called upon in times of need, whether for a plentiful harvest, victory in a competition, or success in a love affair. The *Lares* could be brought out to the table to share in a formal family meal.

Along with supplication and a prayer of thanks, offerings included wine, fruits, nuts, honeycomb, flowers, and garlands. Incense and the remains of animal sacrifices were burned; some altars at Pompeii still bear the traces of their last offering.[72] Lamps found in *lararia* provided light for prayers at night and also served as offerings in their own right, just as today one might light a candle in a Catholic church.[73]

In another rumination on idyllic country life, Horace explains that even humble gifts of grain and salt can mollify the household gods:

If you raise your upturned hands to the sky
when the moon is born anew, Phidyle, my country lass;
if you placate the Lares with incense,
with this year's grain, and with a greedy sow,

. . . your vine will be fruitful . . .
 nor will your crops know the blight of mildew

. . . but it is not for you to pester
the little gods whom you decorate with rosemary
 and brittle myrtle by slaughtering numerous sheep.

If a hand has touched the altar without any gift,
not made more persuasive by an expensive victim,
it softens the displeasure of the Penates
by reverent grain and sputtering salt.
 (*Odes* 3.23)

Figure 22
John William Waterhouse (British, 1849–1917), *The Household Gods*, about 1880. Oil on canvas, 103 x 74 cm (40 ½ x 29 ⅛ in.). Private collection.

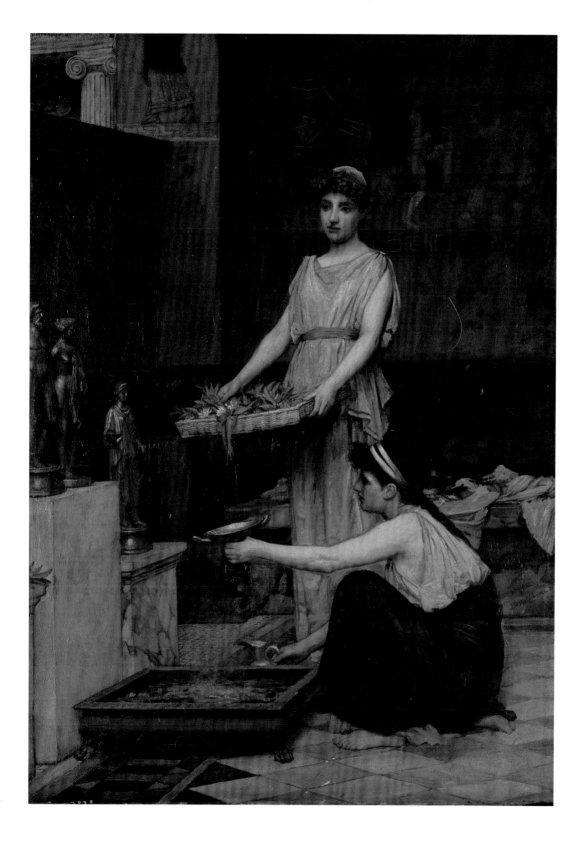

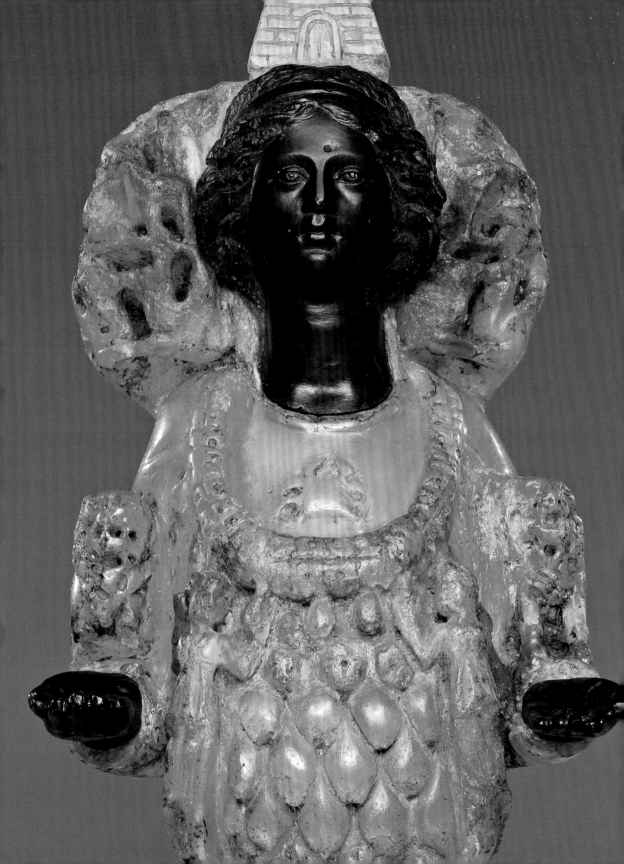

And the Greeks in my opinion showed an unsurpassed zeal and generosity in honoring the gods, in that they imported ivory from India and Ethiopia to make images.

—Paus. *Greece*, Elis 2.12.3

Pausanias, one of the world's first travel writers, journeyed around Greece, producing an account of cities and sanctuaries with many digressions into the history and myth of the places that he visited. Born in Lydia in the early second century A.D., he was a Greek from a region that had been part of the Roman Empire for centuries, and his narrative about venerable Greek sites is overlaid with mentions of recent construction and alteration by the Roman emperors. Pausanias's rambling descriptions and personal observations are an invaluable historical source, and effort has been made with some success to match his text with architectural remains on the ground. Much of the ten volumes of his *Description of Greece* concerns temples, shrines, and their artworks—a testament to the prevalence of religious public spaces and sculpture. Thanks to Pausanias, then, we have written



48

evidence for renowned statues (most of which have not survived until today) that complements our archaeological finds.[74] Often the statuettes found in Roman household shrines are miniature versions of some of the most famous cult statues of antiquity. In this chapter we explore these images and the original masterpieces that inspired them.

From Greece to Rome: Original and Copy

In 211 B.C., after three long years of siege, the distinguished Roman general and consul Marcus Claudius Marcellus broke through the defenses of Syracuse in Sicily and laid waste to the city. Syracuse had been the last independent stronghold of the prosperous and powerful Sicilian Greeks; the rest of the island had already decades earlier become the first overseas Roman province. A seasoned commander, Marcellus ordered his soldiers to spare the life of Archimedes, the celebrated mathematician and inventor, whose war machines had held off the Roman attack for so long; but Archimedes was killed in the panic.[75] Sixty-five years later, Rome finally overcame her great rival Carthage, in North Africa. Six days were spent reducing the city to rubble, causing even the victorious general, Scipio, to shed tears at the destruction (Polyb. 38.22).

That same year, 146 B.C., the Greek city of Corinth was brutally sacked by the Roman consul Lucius Mummius, harshly concluding the uprising of the so-called Achaean League of Greek cities. Macedonia and southern Greece came under the control of a Roman governor. Finally, in 86 B.C. the ruthless general Sulla conquered Athens after the city had unwisely allied itself with King Mithradates of Pontus (the northern Black Sea region) against Rome.

The political impact of these victories was immense, heralding the end of the Hellenistic era that had begun with the death of Alexander the Great in 323 B.C. But the cultural impact may have been even greater. The Greek world had fallen to Rome, and to the victor went the spoils of its great wealth and culture. The oft-quoted line by the Roman poet Horace rings true: "Greece, the captive, made her savage victor captive, and brought the arts into rustic Latium" (Hor. *Epist.* 2.156–57).[76]

In reality, the region of Latium and the surrounding area of central Italy had long been exposed to Greek art and architecture.[77] Contacts between Greece and Italy had begun in the eighth century B.C., when sailors and adventurers from the Greek island of Euboea founded a trading post on the island of Pithecusae (modern Ischia) in the Bay of Naples.[78] There they

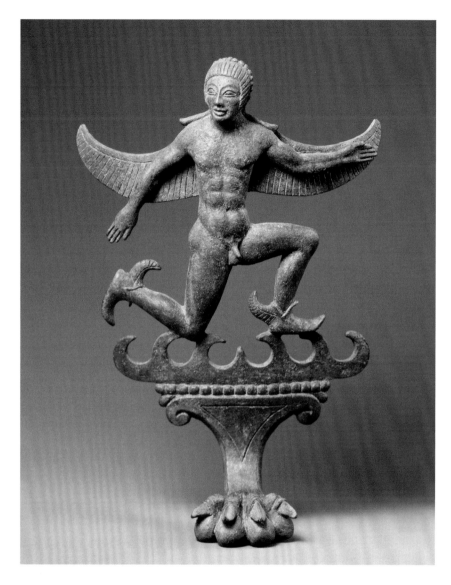

Figure 23
Foot of a *cista* (box) in
the form of a winged
youth. Etruscan, 490 B.C.
Bronze, H: 15.2 cm
(6 in.). JPGM, ACC.
96.AC.127.

encountered the seafaring Etruscans,
inhabitants of the rolling hills of what is
today Tuscany and Umbria. Exploiting
the natural resources of metal ore in
those hills, the Etruscans were skilled
metalworkers, producing their own style
of bronze sculptures and furnishings

(fig. 23). Colonists from the Greek city-
states of Sparta and Corinth soon fol-
lowed the Euboeans, establishing their
own settlements along the southern
coast of Italy. By the sixth century B.C.,
trade between the Etruscans and the
mainland Greeks brought considerable

amounts of Athenian and Corinthian pottery to Etruria, followed by the Greek craftsmen themselves. These traveling artisans shared techniques and ideas, spreading styles across the Mediterranean, and creating new fusion art forms. At the same time, Greek colonies in southern Italy, such as Locri, Metaponto, and Taranto, were growing in wealth and power. They adorned their cities with stone temples, theaters, and other grand public buildings. Greek practices and products seeped inland (the exquisite gold jewelry made in Taranto was highly prized) and were adopted and adapted by native Italic craftsmen and builders. Rome was not immune to these artistic currents, and her public buildings and residential quarters were decorated in a style particularly influenced by her northern neighbors, the Etruscans.

However, at the time of the Roman military victories of the second century B.C. Rome could still arguably be called "rustic," as Horace writes in his playful poem quoted above (p. 48), contrasting the indulgent, intellectual Greeks with the hardy and dour Romans. Following the Etruscan tradition, sculptures were made of terracotta instead of luxurious marble, nor was marble yet commonly used as a building material. Moreover, the sheer scale of the influx of artworks into Rome at this time had a transformative impact on Roman culture, art, and the decoration of Roman homes.[79]

The first wave of foreign objects came as spoils of war. It was customary to grant returning victorious generals a triumph—a parade through the streets of Rome to welcome them home and to show off the booty they had plundered from their defeated enemies. After Marcellus's conquest of Syracuse, he is said to have brought back with him "the adornments of the city, the statues and paintings which Syracuse possessed in abundance" (Livy *Hist.* 25.40.1–3).[80] The historian Livy (59 B.C.–A.D. 17) records that another such triumph included 285 bronze and 230 marble statues, while yet another contained 1,423 pounds of engraved silver vessels.[81] This rampant excess roused the ire of critics appalled at Rome's hubris and vanity, bemoaning the fact that "even gods were led about in her triumphal processions like captives" when statues of deities were ripped from foreign temples (Plut. *Life of Marcellus* 21.1). Perhaps the fiercest critic was Cato, a staunch supporter of the old-fashioned Roman ways: "Tokens of danger, believe me, were those statues that were brought to this city from Syracuse. Altogether too many people do I hear praising and wondering at the baubles of Corinth and Athens and laughing at the terracotta antefixes of our Roman gods" (Livy *Hist.* 34.4).

The flow of sculpture and paintings into Rome was unstoppable, however. While many items went into the private homes of the elite, others were displayed in temples and public buildings. As symbols of military dominance and of the power and newly found sophistication of the Roman senatorial class, these artworks became highly desirable for all levels of society, sparking a fashion for Greek-style ornaments and furniture for villas and townhouses across Italy. To meet the growing demand for antique sculpture, the second and third waves of Greek artworks were imported to Rome on merchant ships. Enterprising craftsmen created replicas and adaptations of the most popular fifth- and fourth-century-B.C. sculptures for the Roman domestic market.

The relationship between original and copy in Greek and Roman art is complex and difficult to unravel, especially because for the most part it is only the copies that have survived. Moreover, although we know from literary accounts such as Pausanias's that many Greek masterpieces were made in bronze, most of our existing versions are in marble. That necessitated changes in the structure of the piece to support the heavier stone. Most "Roman" copies of Greek works were actually made by Greek sculptors, who worked in Greece or emigrated to Italy.

These difficulties are compounded by the lack of secure archaeological contexts for so many pieces and the problems of accurately dating statues. While there are some innovations in stone-carving and bronze-working techniques that help to date pieces, most sculptures are dated on the basis of their style. Because copies could deliberately aim for a precise imitation, we sometimes cannot tell for certain whether a given piece was made in the late Classical and Hellenistic period, that is, before the Roman conquest of Greece, or in the centuries after.

Moreover, certain materials lent themselves to production in multiples. Terracotta statuettes were mass produced using molds that were easy to distribute and share between workshops.[82] Likewise, full-scale bronze statues as well as smaller figurines could be made from re-usable molds.[83] Variations in scale reflected the different demands of public or private display. While there was often a famous "original" that was used as a prototype, these types took on lives of their own, with artists playing with conventional iconography and creating distinct versions.

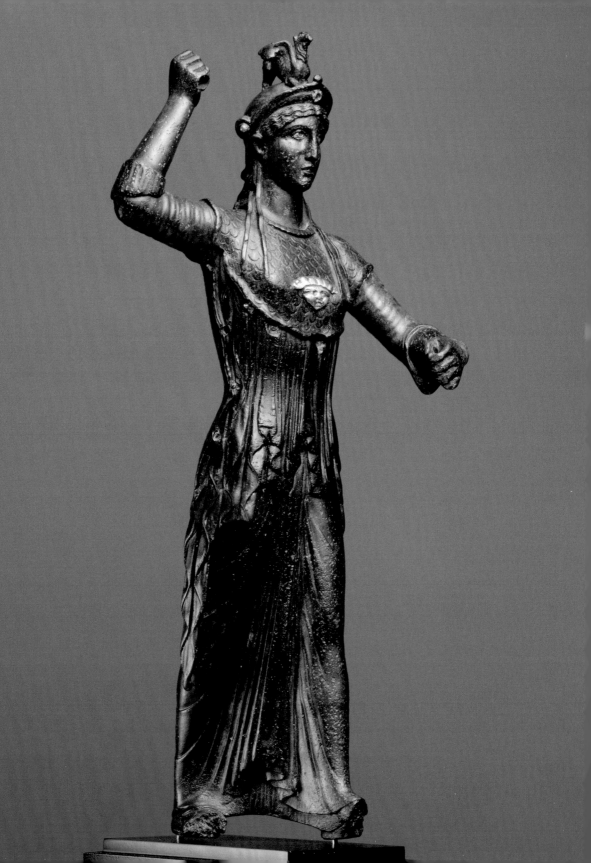

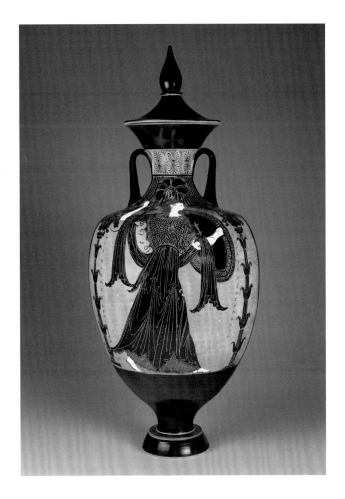

Figure 24
Statuette of Athena
Promachos (first
fighter). Roman, about
50 B.C.–A.D. 25. Bronze
with silver inlays, H: 20.6
cm (8⅛ in.). JPGM, acc.
96.AB.176.

Figure 25
Panathenaic prize
amphora with Athena.
Greek (Attic), attributed
to the Painter of the
Wedding Procession as
painter and signed by
Nikodemos as potter,
363/2 B.C. Terracotta, H:
89.5 cm (35¼ in.). JPGM,
acc. 93.AE.55.

Archaizing Athena

A bronze statuette of Athena, god-
dess of war and wisdom, advancing
into battle (fig. 24), would have held
a spear in her raised right hand and
a shield on her left arm (perhaps of
silver, as the precious metal is used to
ornament other features of the piece,
such as her eyes and the crown of her
helmet). Conventionally known as
Athena *Promachos* (although the type

was not called that in antiquity), bronze
figurines of the warrior goddess standing
armed and holding her spear over her
head date from the sixth century B.C.,
echoing depictions of male warriors and
of the war god Ares in the same stance.[84]
Athena wears a sleeved *chiton* (a cloth
tunic fastened at the shoulders or along
the arms) covered by a cloak falling in
folds down her right side. Her protective
aegis (breastplate) hangs in a semi-circle
over her chest; this is Athena's magical
scaled armor, adorned with a central
silver Gorgon's head and edged with
silver snakes that are now missing. Her
Athenian-style helmet is topped by a
crouching griffin, a mythical creature
that is part-lion and part-eagle.

The same type of Athena was por-
trayed on Panathenaic prize amphorae
(fig. 25). The Panathenaic games were
held at Athens every four years, starting
in 566 B.C. Winners received a valuable
prize—a large *amphora* (two-handled
storage jar) filled with olive oil made
from the trees in Athena's sacred grove.
These amphorae commemorated the
victory by showing the athletic event (in
this case a boxing match) on one side
and the goddess on the other. The style
of the prize vessels remained remark-
ably unchanged over many centuries.
Although the potter Nikodemos made
this one in 363/2 B.C. (he signed his
name in careful letters next to the

54 left-hand column), the painter has deliberately retained the black-figure style that would by then have looked old-fashioned to contemporaries.

The Athena statuette made in the late Republican or early Imperial period is likewise intentionally archaizing, as art historians call it, harking back to the artistic style of the earlier Archaic period.[85] The most famous version of Athena *Promachos* was a colossal bronze statue by the Greek sculptor Phidias (active about 465–425 B.C.) that stood outdoors on the Acropolis in Athens. Pausanias tells us that the statue was commissioned out of the spoils from the Greek victory over the Persians at Marathon in 490 B.C., and that it was so tall that "the point of the spear of this Athena and the crest of her helmet are visible to those sailing to Athens, as soon as [Cape] Sounion is passed" (Paus. *Greece* 1.28.2). Although her exact attributes are disputed, the statue retained the stiff frontal pose and heavy, traditional clothing of the Archaic style that had passed out of fashion decades before it was made.

Standing only about 20 cm high, a fraction of Phidias's 9-m (30-foot) colossus, and produced more than five hundred years later, this elegant version was most likely set up in a Roman household shrine. Dating to the time when Rome was embroiled in or recovering from civil war, the military aspect of the goddess no doubt evoked her Roman equivalent, Minerva. In its archaizing style, the statuette further reflected the antique image of the Palladium, the sacred wooden statue of Athena brought to Rome from Troy by Aeneas (see figure 18).

Divine Perfection

The ancient Greeks believed that being beautiful on the outside was a reflection of a good person on the inside. Aristocratic youths could be termed *kalokagathia* (best and brightest), making explicit this connection between external perfection and internal virtue. Upperclass young Greek men spent time training at the gymnasium, a place of both physical and intellectual education. There they prepared for battle, political life, and athletic competition and paraded their oiled and toned bodies, for most sports were practiced in the nude in Greece. Athletic excellence, physical beauty, good birth and character, and wealth were all part of the package of the ideal man. While women were depicted clothed, freestanding sculptures of male gods, heroes, warriors, and athletes were almost always nude.[86] In addition to allowing the *kalokagathia* to shine

Figure 26
Statuette of Jupiter. Roman, first century A.D. Silver, H: 17.5 cm (6 ⅞ in.). JPGM, acc. 77.AM.26.

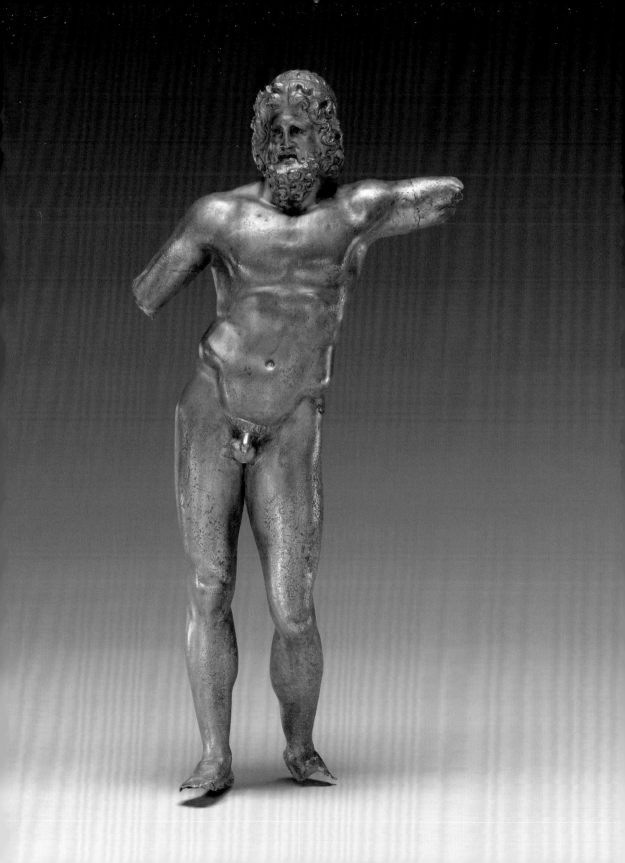

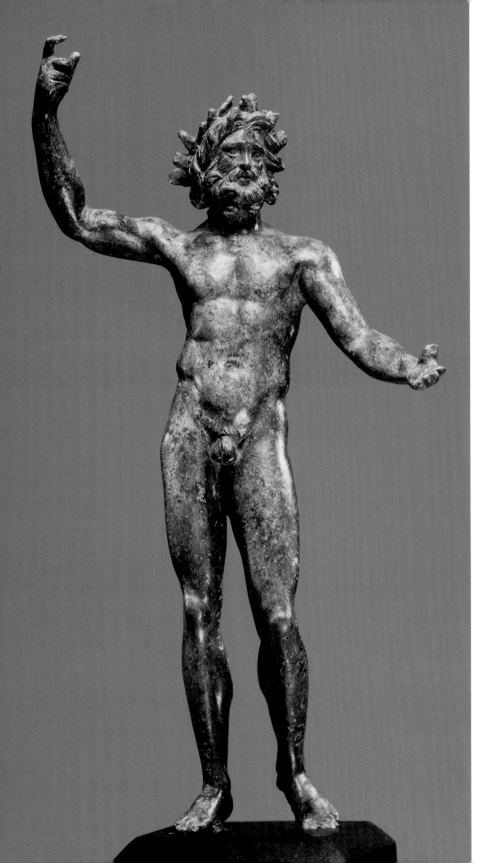

Figure 27
Statuette of Poseidon.
Greek, about 120–100 B.C.
Bronze, H with tang: 16.4
cm (6 ½ in.). JPGM, acc.
96.AB.151.

Figure 28
Statuette of Apollo.
Greek, about 100 B.C.
Silver, H: 20 cm (7 ⅞ in.).
JPGM, acc. 96.AM.304.

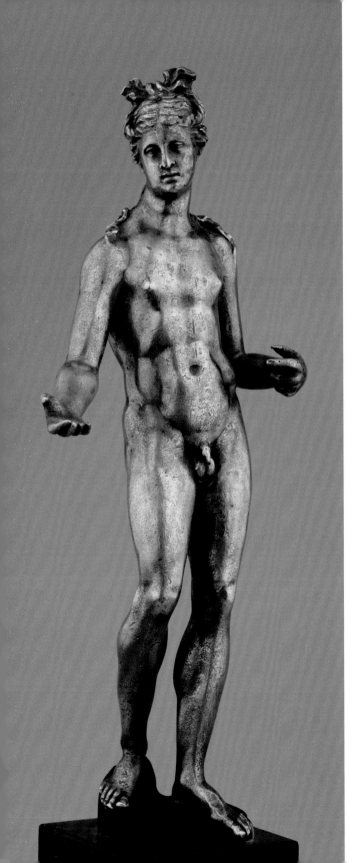

forth, the representation of the naked body gave the sculptor the opportunity to create virtuoso effects in depicting strong or sinuous backs and muscular chests and legs.

The Greek sculptor Polyclitus (active about 460–420 B.C.) composed a treatise (the *Canon*) explaining his method for creating the ideal male form, based on achieving an exact proportion between all the elements of the human body, from the fingers to the feet. The *Canon* was exemplified by his own sculptures, in particular the *Doryphoros* (spear-bearer), a nude who leans on his spear, resting his weight on his back leg to throw out the opposite hip and create a sense of tension and movement. As Greek art developed, other sculptors experimented with the curving stance and finding balance in the arrangement of the limbs. Derived from this type, a Roman statuette of Jupiter would have rested his left arm on a scepter while his right hand held a lightning bolt (fig. 26). Working in bronze as opposed to stone allowed artists to free the arms from the body, projecting them out into the space of the viewer. By the late fourth century B.C. the Greek sculptor Lysippus (active about 370–315 B.C.) had stretched out the nude statue, giving it a slender body with long limbs that appeared lighter and freer and a small head to create the illusion of height. A

58 figurine of Poseidon exemplifies these Lysippan charateristics. Leaning on a tall trident (now missing) the god would have supported a little dolphin on his outstretched left arm; he wears a crown of spiky water-plant leaves (fig. 27). In a silver statuette of Apollo, the lithe body and delicate limbs enhance the effeminacy of the portrait of the long-haired god (fig. 28).

Made in bronze and silver, these small-scale versions perhaps come closer to lost fifth- and fourth-century bronze originals than do full-size marble copies, and they capture the beauty, grace, and dazzling effect of these musings on the ideal body.

City Symbol

Certain gods and goddesses were closely tied to a specific city. As a result, images of that deity, and in particular the main cult statue housed in the principal civic temple, became emblems of that city. Such a cult statue might appear on coins minted in the region, and miniature versions were immediately recognizable as being associated with the place as well as the deity. One such cult statue is the so-called Artemis of Ephesus (fig. 29).

Artemis and her twin brother Apollo were the divine offspring of Zeus, king of the gods, and a mortal woman named Leto. According to the myth, Zeus's jealous wife, Hera, chased the pregnant Leto across Greece to prevent her from giving birth. The nymph Ortygia took pity on the exhausted Leto, allowing her to rest on her island (Delos), where the twins were born under a palm tree, which henceforth became a symbol of Apollo. However, the inhabitants of Ephesus, a city in Asia Minor, preferred another version of the story, in which Leto gives birth there in a grove called Ortygia. Claiming to be the birthplace of Artemis, the Ephesians took her as their savior goddess. The cult of Artemis of Ephesus was a so-called mystery cult, a facet of ancient religion that involved initiating members through secret ceremonies and a direct encounter with the divine.[87] Sworn to secrecy, participants seem to have followed the rules, for we can uncover little about these cults today. However, the huge Temple of Artemis at Ephesus was renowned as one of the Seven Wonders of the Ancient World, and the city celebrated an annual festival on May 6 in honor of the goddess's birthday to ensure another year of her protection.[88]

The very distinctive iconography of the Artemis of Ephesus is not the typical depiction of Diana/Artemis, the virgin hunter, who is often portrayed running with a bow and arrow, her practical short dress whirling around her, and her

Figure 29
Statuette of Diana (Artemis) of Ephesus. Roman, second century A.D. Alabaster, H: 30.8 cm (12 ⅛ in.). JPGM, acc. 81.AA.134.

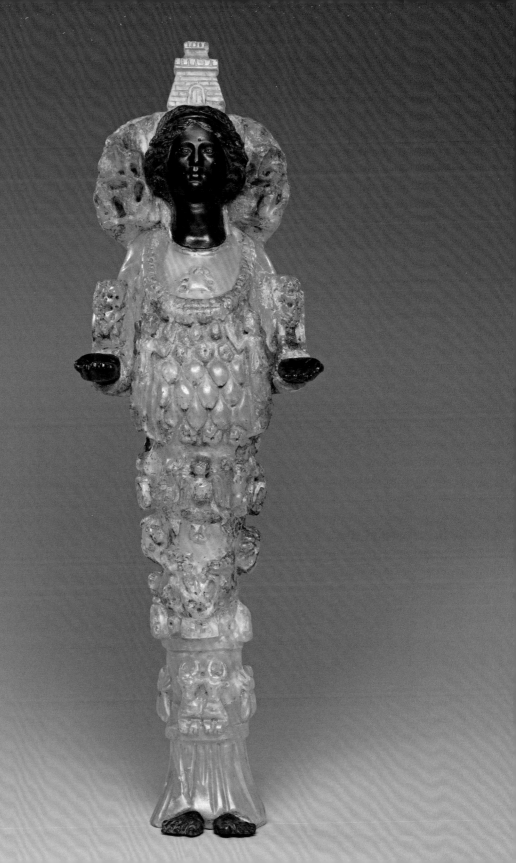

60 cloak tied around her waist. Instead, the Ephesian version celebrates Artemis's role as *Potnia Theron* (mistress of the beasts) and her connection to Eastern mother goddesses.[89] Her rigid tiered skirt is decorated with animals, including bees, bulls, and sphinxes, and she wears a mural crown to represent her favored city. Most unusual of all are the ovoid protrusions hanging in rows from her chest. Their meaning has baffled scholars, and they have been variously interpreted as breasts, eggs, the scrota of bulls sacrificed during her mysteries, amber pendants, or bee cocoons. This stunningly detailed alabaster statuette captures the features of the full-sized cult statues found at Ephesus. The use of a contrasting material (dark stone or bronze) for the head, hands, and feet parallels other replicas.[90]

Imperial Influence

Not only icons from Greek cities and temples became popular miniatures. A small bronze figurine copies the cult statue of Mars *Ultor* (the avenger) set up in his temple in the Forum of Augustus at Rome (fig. 30). The god stands with his cloak running behind his back and looped around the front of his right arm, which is raised to grip a spear (now missing). His left hand may have

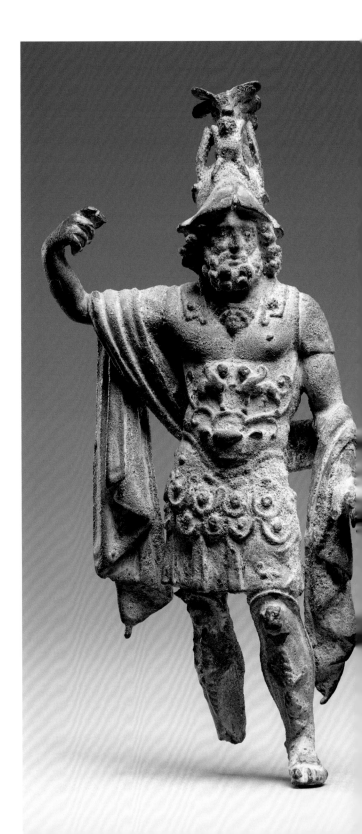

rested on a shield and/or held a sword. Hanging down over his short military tunic, the heavy *cuirass* (breastplate) is decorated with two facing griffins and a Gorgon's head at the neck. Mars is bearded, with thick curly hair, and his elaborate Corinthian-style helmet is topped by two more griffins flanking a central sphinx.

During his pursuit of Brutus and Cassius, the main conspirators in the assassination of his adopted father, Julius Caesar, Octavian, the later emperor Augustus, promised a temple to this vengeful version of the god of war; in 42 B.C. Octavian defeated the conspirators at the Battle of Philippi, in eastern Macedonia. The vast, lavishly decorated marble temple, finally inaugurated forty years later, had at its center a huge statue of Mars *Ultor*, now lost. A torso from the neighboring Forum of Nerva comes from a later version of the cult statue and is our definition of the type. Now in the Capitoline Museums at Rome, it has been restored as a complete figure. Our figurine, only 10 cm (4 in.) high, replicates aspects of the Capitoline torso with remarkable fidelity. Small enough to be easily carried by hand, such statuettes of Mars are found spread across the Roman provinces, perhaps a favorite for soldiers to carry on campaign for worship and protection.[91]

When approaching the figurines set up in a household shrine in the Roman period, some family members would have been aware of the existence of original Greek "antiques" in temples and public spaces. Pliny catalogues the pieces by famous Greek sculptors that could still be seen in Rome at his time, in the first century A.D.[92] Some people may have seen these sculptures in person, conjuring up memories of the trip as well as the artwork. Others would have been aware from the bombardment of images on everyday items such as coins, lamps, and jewelry, that this was the proper form for a representation of that deity. Whether deliberately or not, the use of these miniature masterpieces brought part of the legacy of Greek culture into their homes and illustrated the power and reach of the Roman world.

Figure 30
Statuette of Mars *Ultor*
(avenger). Roman,
second century A.D.
Bronze, H: 10.3 cm (4
in.). JPGM, acc. 96.AB.194.

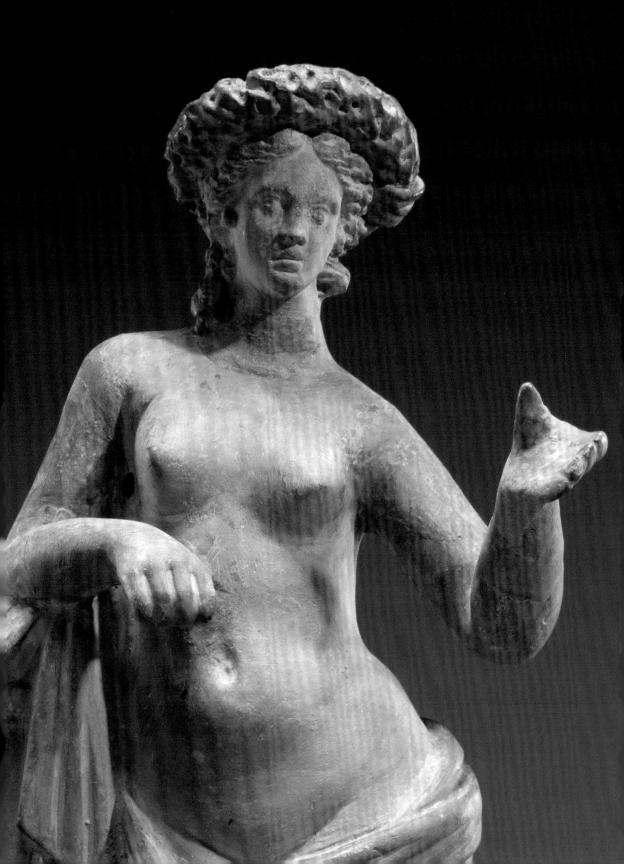

In a corner I saw a large cupboard containing a tiny shrine, wherein were silver Lares, and a marble image of Venus, and a large golden box, where they told me Trimalchio's first beard was laid up.

—Petron. *Sat.* 29

In the *Satyricon*, a Roman novel written by an imperial courtier named Petronius during the reign of Emperor Nero (ruled A.D. 54–68), the narrator goes to a dinner party at the house of a certain Trimalchio (Petron. *Sat.* 27–78).[93] Trimalchio is a freed slave who through luck and industry has become very wealthy and now possesses many estates and slaves of his own. The story is an ancient parody of the *nouveau riche*, which preserves a remarkable view into the perceptions and tastes of the Roman elite. The description of Trimalchio's home, the food served, and the conversation and entertainment that he provides echoes much that we can correlate with archaeological evidence from Rome and luxury villas around the Bay of Naples. But here it is taken to the extreme: hors d'oeuvres of false eggs stuffed with bird meat and yolk are served under a wooden hen, followed by a dish with foodstuffs

arranged to match the twelve signs of the Zodiac, with fish for Pisces and scales weighed down with cakes for Libra. Later a centerpiece is brought out wherein a cooked hare has been fitted with wings to resemble the mythical flying horse Pegasus. The presentation is astonishing, but the ingredients are mainly common and homegrown. The wine is a vintage from the renowned Falerian region, but being more than a hundred years old, it would most likely have tasted dreadful. The cutlery is heavy silver, and the plate is special "Corinthian" bronze, a faddish tableware erroneously associated with Rome's Sack of Corinth in 146 B.C., which Trimalchio has bought from a dealer named Corinthus, thereby making a joke of the origin of "Corinthian." Trimalchio regales his guests with mythological and historical tales but mixes up the characters, confusing the murderous queen Medea with the doomed Trojan princess Cassandra, and completely muddling the events of the Trojan War as told in Homer's epics. The elite audience of the *Satyricon* is expected to laugh at Trimalchio's gross excess, gauche misunderstandings, and overblown pride.

Composed very close in time to the destruction of Pompeii (A.D. 79) and set near the Campanian city of Cumae, the *Satyricon* mocks the spread of luxurious living during the first centuries B.C. and A.D. that we can observe in actuality through the material remains of the towns and country villas preserved by the eruption of Mount Vesuvius.[94] There we find that even smaller residences, from two-room apartments to family homes of average-size, are decorated with painted walls and mosaic floors. The grandest houses have multiple dining rooms with positions dictated by the seasons to be warm in the winter and cool for the hot summer months. Elegant gardens are filled with statues and fountains, as well as fruit trees, vines, and vegetable plots for the kitchen. Wall-paintings, such as an example from the so-called House of the Chaste Lovers at Pompeii (fig. 31), show men and women bedecked with jewelry reclining on couches draped with soft fabrics and drinking from glass and silver vessels set on low tables.[95] Enabled by the social mobility embedded in the practice of manumitting slaves and permitting their offspring to be born free Roman citizens and by the economic opportunity of trades such as baking, clothes laundering, and shipping, even the lower classes of society could aspire to share in the lifestyle of which Trimalchio's home was an outrageous example. Although criticized by Roman moralists, luxury goods imported from Greece, Egypt, and the Near East diffused through the Roman domestic sphere from the highest to the lower levels.

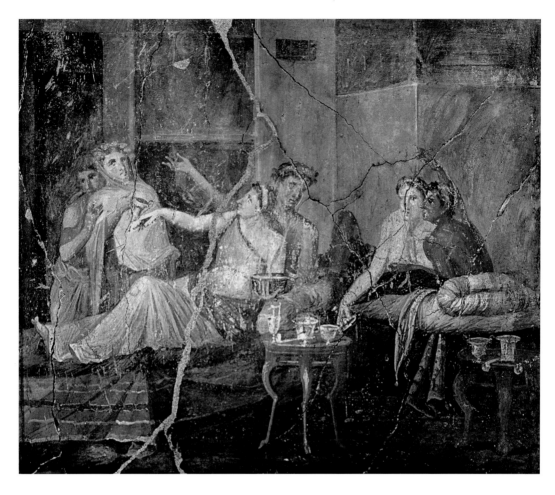

Figure 31
Wall-painting in the
triclinium (dining
room) of the House
of the Chaste Lovers
(IX.12.6–8) in Pompeii.
Two couples recline on
couches indoors during
a drinking party scene.
Roman (from Pompeii),
A.D. 1–79. Plaster and
pigment.

For our purposes here, we are interested in the brief description of Trimalchio's household shrine, quoted at the head of this chapter.[96] The shrine is positioned near the entrance to the house—one of the more common locations for shrines, along with the kitchen and gardens—in a public area well suited to an owner who wanted to show off.[97] The shrine is described as being "in a cupboard"[98] (compare fig. 15). The *Lares* are made of silver, and there is a

golden box containing the trimmings from Trimalchio's first shave. Although Petronius's account is fictional, silver *Lares* are deliberately ostentatious; while several silver statuettes are recorded from Pompeian domestic shrines, none of them depicts the *Lares*, which were normally made of bronze.[99] The beard trimmings symbolize the transition from boy to man, an important rite of passage for a youth in antiquity. Trimalchio's pride in his rags-to-riches

66 life-story—born a slave in Asia Minor, he has become a wealthy Campanian land-owner—is manifested by this precious memento, which he has carried with him and enshrined within his home.

It is also notable that Trimalchio's *lararium* includes a marble statuette of Venus (the Greek Aphrodite). The goddess of love is one of the most frequently represented deities in small-scale sculpture for centuries all across the Mediterranean world, and one of the most commonly found in household shrines.[100] It is easy to envision reasons for her popularity—matters of the heart preoccupied the ancients in the same way they do us today. Falling in and out of love on the streets of Rome in the first century A.D. was just as exhilarating and agonizing as it can be more than two thousand years later. Around the turn of the era, the Roman poet Ovid published the *Ars Amatoria* (Art of Love), a bois-terous three-part handbook aimed at both men and women with tips for the best places in Rome to pick up a girl (the theater) and advice for keeping your man (choose a hairstyle that flatters your face shape). Ovid begins his work by evoking Venus as his guide: "If anyone among this people knows not the art of loving, let him read my poem, and having read be skilled in love. . . . me hath Venus set over tender Love as master in the art" (Ov. *Love* 1.1–7).

The heartache of unrequited affection, the passion of illicit affairs, and even the contentment of a loving partnership inspired painters as well as poets; the walls of Roman houses were often decorated with scenes of lovers and lovemaking.[101] These erotic scenes could be couched in the guise of mytho-logical stories, showing Narcissus pining away for his own handsome reflec-tion, the sleeping Ariadne in a state of undress being discovered by Dionysus, or the rape of Cassandra. Others por-trayed more prosaic subjects: from cou-ples that may be the master and mistress of the house, as in the so-called House of the Chaste Lovers (see fig. 31), to the unusual sex acts painted for comic relief in the changing room of the Suburban Bath at Pompeii, or the straightforwardly explicit "menu" of services offered in the brothel down the road. Ancient homes were filled not just with images of the gods but also with images of the gods in love. Depictions of Venus more than any other deity blurred the line between religious symbol and beautiful, even arousing, ornament. The marble Venus in a cupboard in Trimalchio's entrance hall stemmed from an artistic legacy already centuries old and embodied a rich and complex cultural and political significance.

The Naked Goddess

In the mid-fourth century B.C., an Athenian sculptor named Praxiteles (active about 375–330 B.C.) unveiled his latest work—a marble statue of the love goddess Aphrodite—which changed the course of art.[102] Set up in a shrine for the deity in the city of Cnidus on the southwest coast of present-day Turkey, Aphrodite is shown holding her dress in her left hand, next to a water jar, just before or after her bath—the first life-size sculpture of a fully nude woman. The immediate impact of the statue is difficult to determine, for our surviving written accounts date from several centuries later, but at least by the late second century B.C. the Aphrodite of Cnidus had captured the imagination of authors and artists. Throughout the Roman period, it was undoubtedly one of the most famous, iconic, even scandalous Greek sculptures.

Praxiteles' original Aphrodite does not survive. Byzantine accounts record that it was taken to Constantinople in the late Antique period and destroyed in a fire there in A.D. 476. However, from literary descriptions and from the numerous reproductions and adaptations that it inspired, we have a very good idea of what the statue looked like. As can be seen in a Roman version (fig. 32), Aphrodite stands with her knees close together, giving her body a gentle curve. Holding her drapery in her left hand, she turns her head slightly, as if surprised by an observer, and her right hand protects her modesty. Her hair is pulled back in a bun, and her arms may have been ornamented with real metal bangles (compare fig. 39).

The significance of the pose of the Aphrodite of Cnidus has been debated. Is she covering her genitals because she is embarrassed to be seen in the nude? Or are modern interpretations colored by anachronistic Christian ideas of shame and modesty? While Athena and Artemis fiercely guarded their virginity, Aphrodite was aggressively sexual: She is described as adorning her naked body with jewels and glistening oil to pursue her divine and mortal lovers. Moreover, scenes of bathing women on Athenian terracotta pots were already common by Praxiteles' time. Perhaps the issue is instead one of religious propriety. Is it appropriate for a cult statue put on display in a sacred context and intended for worship to show the goddess exposed? A teasing epigram imagines the goddess coming to visit her likeness and wondering: "Paris, Anchises, and Adonis saw me naked. Those are all I know of, but how did Praxiteles contrive it?" (*Greek Anth.* 5.16.168).[103]

Simple terracotta representations of the nude Aphrodite intended as votive offerings are known from the eighth

68 century B.C. onward, following in a tradition that went back several millennia of depicting Near Eastern fertility goddesses naked and cupping their breasts.[104] The Aphrodite of Cnidus uses her strategically placed hand to draw attention to the source of her great power, revealing more than she covers. It is dangerous for the mortal to witness divine nakedness, not for the goddess to be caught exposed.[105] Praxiteles' Aphrodite deploys modesty as yet another weapon in her arsenal to enhance her allure, to place the viewer in ecstatic awareness of her beauty and her sexuality.

Yet, Praxiteles' full-sized sculpture was a radical enough departure from the norm to raise ancient eyebrows. The Roman naturalist Pliny the Elder (writing four hundred years after Praxiteles) relates that the artist apparently produced two identical statues—one showing Aphrodite nude, the other clothed (Plin. *NH* 36.4). Praxiteles put both up for sale and offered first pick to the people on the island of Cos, who rejected the naked goddess and bought the draped version "on the grounds of propriety and modesty." Cos's loss was Cnidus's gain; the nearby city stepped in to buy the rejected statue "and immensely superior has it always been held in general estimation," adds Pliny sagely. Pliny describes the Aphrodite as not only the best work by Praxiteles but as the best sculpture in the world and mentions that visitors traveled to Cnidus to see it as a tourist attraction.[106] The statue became so famous that a Bithynian king, Nikomedes, offered to buy it from the Cnidians in exchange for paying off all of the city's public debt.[107] But Cnidus refused, recognizing that the statue was priceless.

Rumors swirled that Praxiteles used his mistress, the beautiful courtesan Phryne, as his model for the soft curves of the goddess, carving the ideal woman. So great were the charms of the Cnidian Aphrodite that a salacious account spread of a besotted young man who arranged to spend the night in the temple to have his way with the marble flesh, leaving a tell-tale stain on the statue's thigh the next morning (Plin. *NH* 36.4).[108] The statue was installed in a *tholos* (round shrine) where it could be viewed from all sides; male visitors debated whether it was more alluring from the front or the back. Echoing similar stories of men falling in love with the sculptures that they fashioned, the elision between stone goddess and living woman reminds us that ancient marbles were painted to create a realistic appearance. Indeed, the only rival for the beauty of the Aphrodite of Cnidus was said to be a painting by another famous fourth-century-B.C. artist, Apelles, showing the goddess rising from the sea (the *Anadyomene* type). That work was inspired by the

Figure 32
Statue of Aphrodite of Cnidus. Roman copy of Greek original, A.D. 175–200. Marble with pigment, H: 97.2 cm (38¼ in.). JPGM, acc. 72.AA.93.

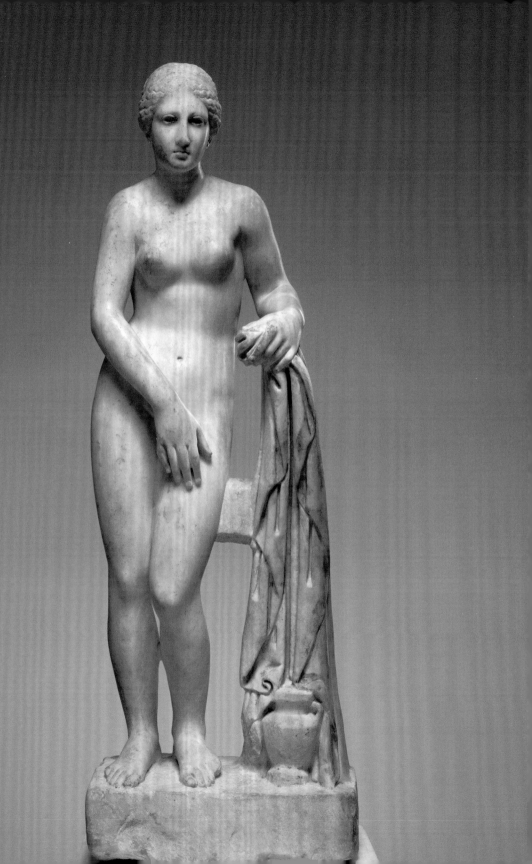

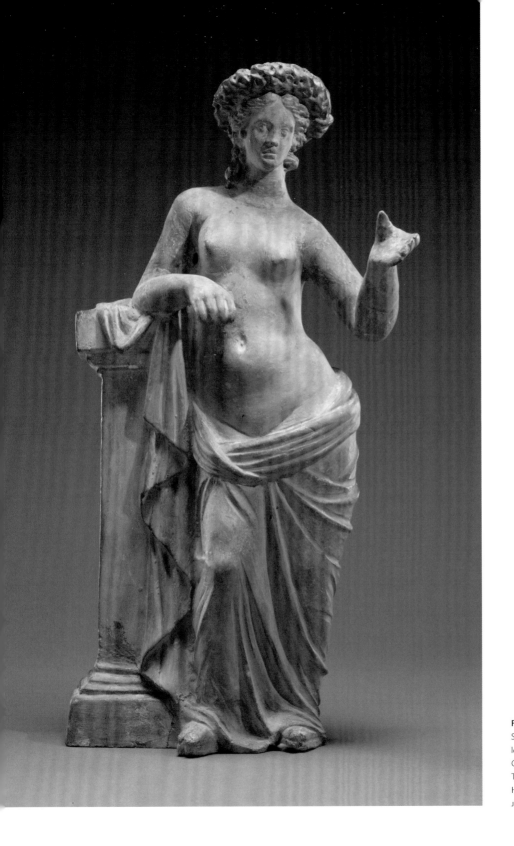

Figure 33
Statuette of Aphrodite
leaning on a pillar.
Greek, 250–200 B.C.
Terracotta and pigment,
H: 27.1 cm (10 ⅝ in.).
JPGM, ACC. 55.AD.7.

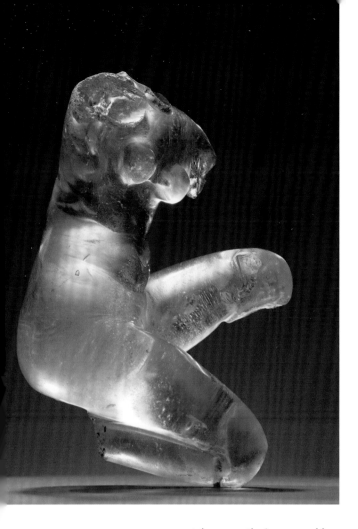

castrated by his son, the Titan Cronus, who acted on the urging of his mother, Gaia (Earth). Aphrodite was born from the foam that surrounded Uranus's mutilated genitals as they fell into the sea. She came ashore on the island of Cyprus, where she was venerated from an early period, especially at Paphos, and her cult spread from Cyprus throughout the Greek world.[110] In texts and dedications the goddess is often referred to as *Cypris* (the Cypriot) or *Paphian*.

Foreshadowing the freer, more emotional artistic style of the Hellenistic period, Praxiteles' Aphrodite of Cnidus opened the floodgates for variations on the theme of the nude Aphrodite. Several main recurring types can be identified. Some show the goddess partially draped, such as Aphrodite leaning on a pillar (fig. 33). Others allow the artist to explore different positions of the female body: Aphrodite wringing out her hair, with her arms up to her head and her elbows out, exposing the full extent of her nudity; Aphrodite bending to fasten her sandal; and the Crouching Aphrodite, such as an exquisite rock-crystal version (fig. 34).[111] As expressed in a epigram attributed to Lucian (born around A.D. 120): "To thee, Cypris, I dedicate the beautiful image of thy form, since I have nothing better than thy form" (*Greek Anth.* 5.16.164).

same mortal woman, the incomparable Phryne. Apelles had admired her at a local Athenian festival when she boldly stripped and waded into the sea in front of a crowd of worshipers, her long hair loose around her.[109]

Depicting Aphrodite at her bath or emerging from the waves might seem designed to justify her nudity, but it also reflects her connection to the sea and her resulting role as protectress of seafarers. According to myth, before the creation of the other gods, Uranus (Heavens) was

Figure 34
Crouching Aphrodite. Greek (Ptolemaic) or Roman, first century B.C. Rock crystal, preserved H: 8.5 cm (3 ⅜ in.). JPGM, ACC. 78.AN.248.

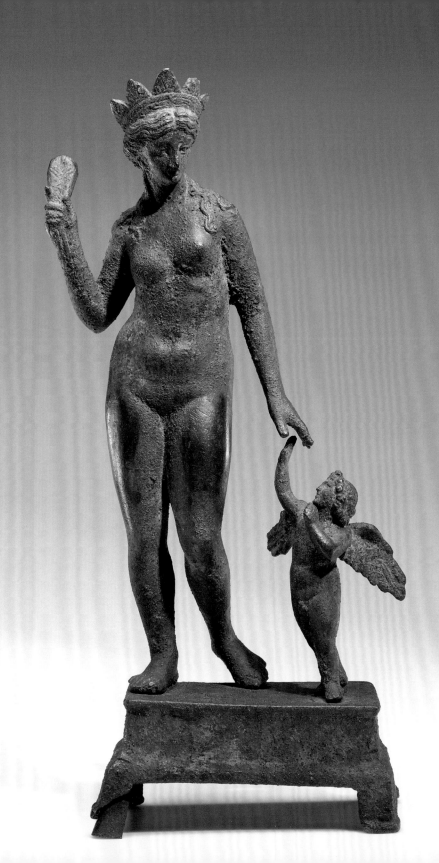

Eros

Eros, known as Cupid to the Romans, was the Greek god of love. The son of Aphrodite (and various possible fathers), he was represented as a young boy with wings and could also be shown as multiple Erotes. Armed with the arrows of love, the cherubic Eros facilitated romance among both gods and mortals. However, the young god had a mischievous, dark side, plaguing men and women with unwanted love affairs and inappropriate passions and tormenting his hapless victims with his keenly aimed darts. Both the Greeks and the Romans lamented the negative aspects of Aphrodite and Eros. Love could be fickle, unrequited, cruel, and even deadly. It was important to keep the love gods placated and on one's side through appropriate worship. A series of statuettes show Aphrodite playfully preparing to punish her naughty son by smacking him with her slipper (fig. 35). Small figurines of Eros, or of Cupid embracing his mortal lover, Psyche, were often placed in household shrines.

Fertility

Life expectancy in antiquity was in general short; many women died in childbirth, and infant mortality was very high.[112] We can see the care lavished on the funerary monuments of young wives and children, whose brief life-span is often recorded to the day or even the hour. Both human and agricultural fertility was of huge concern in the ancient world and the reason behind countless prayers and votive offerings to the gods, especially to Demeter (Roman Ceres), the goddess of grain, crops, and cultivated farming.

Symbols of fertility abounded in homes, gardens, and fields. One of the most dramatic to our eyes, perhaps, is the image of the god Priapus (fig. 36). The child of Aphrodite and the riotous wine god Dionysus, Priapus is characterized by his comically large phallus. The phallus was a potent symbol of protection; phallus-shaped bells, lamps, and amulets brought good luck and warded off evil.[113] Wooden carvings of Priapus were set up like scarecrows in ancient gardens, orchards, and fields to protect the crops from thieves. There were also large-scale stone statues of the god, who is often shown leaning back to counterbalance the thrust of his enormous member.[114] In the home, Priapus was depicted on wall-paintings,

Figure 35
Statuette of Aphrodite and Eros. Greek, second– first century B.C. Bronze, H: 28.7 cm (11¼ in.). JPGM, acc. 57.AB.7.

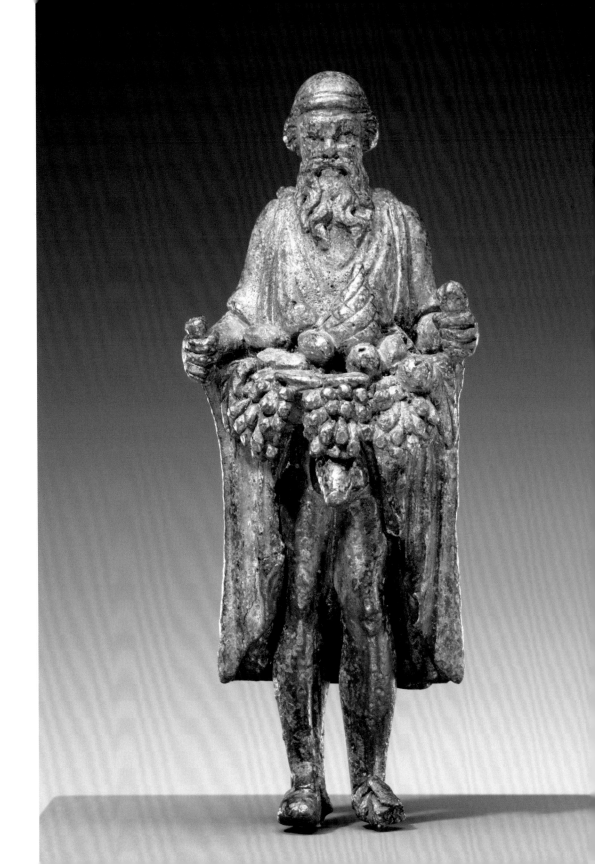

Figure 36

Statuette of Priapus. Roman, first–second century A.D. Bronze, H: 12.3 cm (4 ⅞ in.). JPGM, ACC. 73.AB.21.

and bronze statuettes of him were among the deities included in domestic shrines, where they received prayers and offerings over concerns such as impotence. Priapus also acted as a symbol of prosperity. As part of Trimalchio's lavish feast, the dessert course was served in the form of an edible Priapus, holding up his apron bursting with all kinds of fruits and cakes spurting out saffron juice at the guests when they reached for them. The humorous aspect of the god was a key source of his ability to avert the Evil Eye (see chapter 6).

Goddess of the State

Though Venus was in many respects the equivalent of the Greek love goddess Aphrodite, she also played an important role as the mother of the Roman state and a goddess of victory. Through her affair with the Trojan prince Anchises, Venus was the mother of Aeneas, the legendary ancestor of the Roman people. In the Republican period, she became a favorite goddess of the senatorial elite. Julius Caesar traced his family line back to the union of Venus and Mars and took the goddess as his patron deity, placing images of her on his coinage as a symbol of the divine protection and favor that he enjoyed (fig. 37).[115] Ovid tells us that it was Venus who flew down to bring Caesar's soul up to the heavens when he was deified after his assassination (Ov. *Met.* 15.840–50).[116] When Augustus came to power, aiming to bring order, tradition, and family values back to the corrupted and war-weary state, he initiated a series of marriage reforms to encourage the procreation of legitimate children among the elite. Venus joined Mars as one of the key deities of Rome, and her temple stood next to the huge temple of Mars *Ultor* in the Forum of Augustus (see chapter 4).[117] This political and public union of Venus with Mars carried great irony (recognized at the time), for

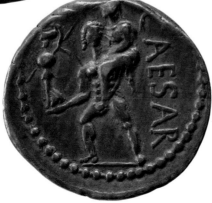

Figure 37

Coin of Caesar with obverse head of Venus and reverse of Aeneas carrying Anchises on his shoulder and the Palladium in his hand. Roman, minted 47–46 B.C. Silver, weight: 3.44 grams. London, The British Museum, inv. 1937,1004.20.

according to myth the two deities had an affair with each other behind the back of Venus's unattractive husband, the blacksmith Vulcan. This love triangle and the potent dichotomy between Love and War have aroused considerable fascination for authors and artists. In a seventeenth-century painting by Rubens and Breughel the Elder, Venus disarms her lover in the very workshop of her husband (fig. 38).

One might imagine that the prevalence of Venus in domestic cult was due to her role as goddess of love. However, as seen in a stunning statuette, she had a strong political and matronal aspect (fig. 39). Leaning on a scepter (now lost) and wearing a crown, her dress and pose are regal rather than seductive. The marble Venus in the fictional household shrine of the freedman Trimalchio, therefore, could represent the mother of the Roman state, as well as the sensuality of Aphrodite.[118] With Venus able to embody such a myriad of meanings, it is perhaps not surprising that she was one of the most popular deities worshiped by Romans in the private sphere.

Figure 38
Peter Paul Rubens (Flemish, 1577–1640) and Jan Breughel the Elder (Flemish, 1568–1625), *The Return from War: Mars Disarmed by Venus*, about 1610–1612. Oil on panel, 127.3 × 163.5 cm (50 ⅛ × 64 ⅜ in.). JPGM, acc. 2000.68.

Figure 39
Statuette of Venus. Roman, second–third century A.D. Gilt silver, H: 19.2 cm (7 ½ in.). JPGM, acc. 76.AM.4.

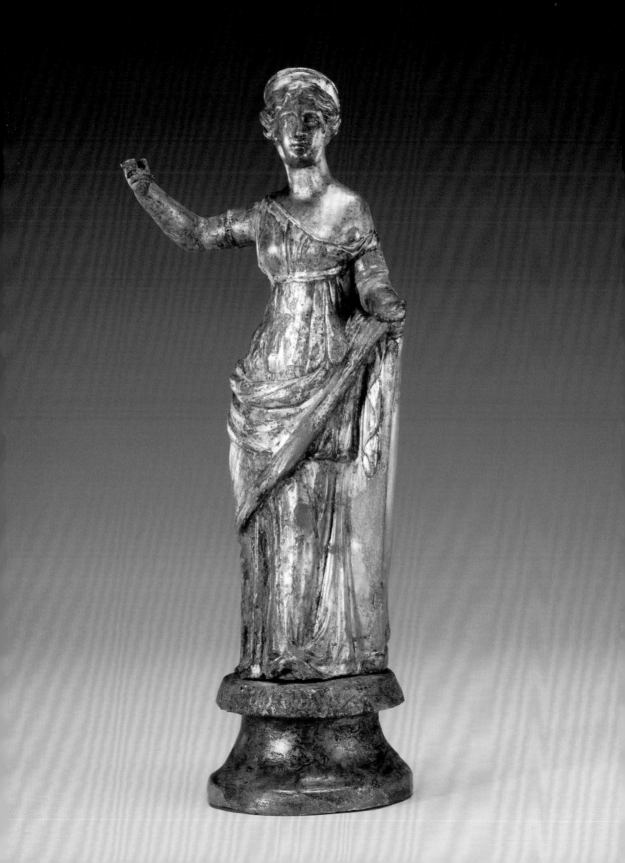

6 DIVINE FAVOR:
LUCK AND MONEY

For a moment my uncle wondered whether to turn back, but when the helmsman advised this, he refused, telling him that Fortune stood by the courageous.

—Plin. *Let.* 6.16

In A.D. 79, the Elder Pliny—Roman general, naturalist, and scholar (A.D. 23/4–79)—was stationed at Misenum on the Bay of Naples as commander of the Roman fleet there. In the early afternoon of August 24, the day of the eruption of Mount Vesuvius, his attention was drawn to a cloud on the other side of the bay that his nephew would later describe "as being like a pine . . . for it rose to a great height on a sort of trunk and then split off into branches."[119] Pliny could not help but be spurred to action, not only by his humanitarian desire to attempt a rescue of people trapped in the vicinity of the volcano, but also by his inquisitive nature.[120] His great work, *Natural History*, contains sections on volcanic and other seismic phenomena. Pliny ordered a boat to be readied and set sail for the coast near the erupting volcano. Some twenty years later, Pliny the Younger, who was staying with his uncle and namesake at

the time, wrote an account of the ensuing events in two letters to the historian Tacitus (about A.D. 56–after A.D. 118) to ensure that the record for posterity was "as reliable as possible."

When Pliny the Elder's boat neared the coast, shoals of pumice floating on the water prevented them from reaching the shore. He landed on a beach to the south and spent the night at a friend's villa. The next morning steadily falling pumice had put dangerous weight on the roofs of the villa, so they made for the shore to see if it was possible to set out to sea, but the water was still too violent. The air thick with ash and the day dark as night, Pliny settled on the beach on a sail spread out for him. Flames in the near distance and the smell of sulphur caused his companions to flee, leaving Pliny alone on the sand. Sadly, Fortune was not on Pliny's side. When daylight returned the following day, his body was found: He had died on the beach, overwhelmed by the fumes.

For the Greeks and Romans, fortune was more than just a concept, she was a goddess whom you needed to keep on your good side lest she turn against you.

Tyche and Fortuna

By the end of the fourth century B.C., the sudden rise and extraordinary military success of Alexander the Great had brought an end to the independence of the Greek city-states and dramatically expanded the political and cultural reach of the Greeks deep into Asia. Alexander's early death at Babylon in 323 B.C. on his return journey from India ushered in the period of the Hellenistic kings, rulers styling themselves on eastern precedents. This change and uncertainty heightened the appeal of "new" deities, such as Tyche, the goddess of chance or luck.[121] While divine personifications of abstract concepts existed already in the Archaic period, by the fourth century B.C. there was a wide array of such deities, including *Eirene* (Peace), *Plutus* (Wealth), and even *Democratia* (Democracy).[122] Tyche is attested beginning in the fourth century B.C. from inscriptions found on the islands of Thera and Rhodes. She could bring both positive and negative outcomes, and *Agatha* Tyche (Good Fortune) was venerated as the preferred version of the deity.

In addition to watching over the fate of an individual, Tyche could also affect the fortune of cities, and some adopted her as their patron deity. A particularly famous version was the Tyche of the

Figure 40
Statuette of Tyche of Antioch. Roman, second century A.D. Bronze, H: 12 cm (4 ¾ in.). JPGM, acc. 96.AB.196.

eastern city of Antioch in present-day Syria (fig. 40). Situated on the River Orontes, Antioch was founded during the fallout from the death of Alexander the Great due to the lack of a clear successor. Seleucus I (about 358–281 B.C.), one of Alexander's generals, whose descendants would rule successfully over the region for the next two hundred years, established his royal capital at Antioch. The cult image sculpted by the artist Eutychides (late fourth century B.C.) for the new foundation shows Tyche swathed in thick drapery, seated and wearing a crown in the shape of a city wall to signify that she was a city goddess. In her now-missing right hand she held a sheaf of grain as a symbol of prosperity. This image was widely copied and spread during the Roman period for use in private devotion.

The Greek Tyche was assimilated to the existing Roman goddess Fortuna. In origin a fertility goddess, Fortuna took on the characteristics of Tyche as a deity of luck and chance and a (potential) bringer of prosperity and good fortune. The cruelty of both goddesses is bemoaned in literary texts and inscriptions, especially because their harsh punishments are seen as arbitrary and undeserved rather than informed by a sense of justice. Later, Tyche and Fortuna also came to be associated with the omnipotent Egyptian savior goddess Isis (see chapter 8), perhaps in an attempt to mitigate their negative potential.

The Roman Fortuna was worshiped with several attributes. At her huge sanctuary at Praeneste, a short distance from Rome, built on the model of the great Hellenistic royal palaces with several tiered terraces climbing dramatically up the steep hill on which it stood, the goddess was venerated as Fortuna *Primigenia* (firstborn). There her fertility aspect came to the fore. Women left offerings related to childbirth, and there was also an oracle that could be consulted. Fortuna was commonly depicted standing or seated, holding a cornucopia for fertility and the rudder with which she could steer the course of an individual's life, and resting her foot on an orb as a symbol of her instability (see fig. 49).

The unpredictability and randomness of life events gave rise to many attempts on a personal level to effect some control over one's circumstances. Conceiving of chance as a goddess who could be influenced in one's favor no doubt brought some comfort from the vicissitudes of daily life.

The Evil Eye: Superstition and Amulets

The biographer of emperors, Suetonius (born about A.D. 70), reports the following habits of Emperor Augustus:

He was somewhat weak in his fear of thunder and lightning, for he always carried a seal-skin about with him everywhere as a protection. . . . He was not indifferent to his own dreams or to those which others dreamed about him. . . . Certain auspices and omens he regarded as infallible. If his shoes were put on in the wrong way in the morning, the left instead of the right, he considered it a bad sign. If there chanced to be a drizzle of rain when he was starting on a long journey by land or sea, he thought it a good omen. . . . But he was especially affected by prodigies. When a palm tree sprang up between the crevices of the pavement before his house, he transplanted it to the inner court beside his household gods [*Penates*] and took great pains to make it grow. . . . He also had regard to certain days, refusing ever to begin a journey on the day after a market day or to take up any important business on the *nones*.

(Suet. Aug. 90–93)

Although superstition (as oppose to proper religious practice) was regarded with skepticism and deep mistrust by some of the intellectual elite Roman politicians, poets, and historians whose writings survive, the description above illustrates the sort of practices that were commonplace at all levels of society: following dreams and premonitions, believing that certain days of the month were unlucky, and careful regard for natural phenomena. There was a very fine line between accepted religious ritual and behavior that verged into the realm of magic.[123] While public cult involved the consultation of oracles and the interpretation of omens, these practices could be viewed with suspicion when carried out privately by men, and especially by women. Yet *magi* (magicians) hawking their services in the marketplaces could command considerable fees. Perhaps unsurprisingly, love spells and potions were particularly sought after to encourage the affections of a beloved. For enemies, curse tablets were used to seek revenge. These tablets consisted of a thin sheet of lead onto which a curse was scratched. The sheet was then rolled around some magical herbs or folded up and pierced with iron nails and thrown into a pool or well, buried within a building, or deposited in a freshly dug grave or a pit sacred to chthonic (belonging to the Underworld) deities who would carry out the requested harmful actions. Curses ranged from asking the gods of the Underworld to render mute an opponent in a law case to wishing ill health on a thief.[124]

The practice of carrying amulets, especially of precious stones, and a belief in the homemade remedies of "old wives tales" was widespread. Pliny the Elder doubtfully relates weird and wonderful customs in his *Natural*

84 *History,* often attempting to debunk the efficacy of these practices: "[The *magi*] say that if amethysts are inscribed with the names of the sun and the moon and are worn hanging from the neck along with baboon's hairs and swallow's feathers, they are a protection against spells" (Plin. *NH* 37.40).[125] Amber was a highly prized material for amulets due to its medicinal and electromagnetic properties as well as its beauty.[126] Naturally warm to the touch, it was thought to radiate the captured sun. Pieces of amber were carved into the shapes of animals and human heads (fig. 41). Young Roman citizen boys wore protective amulets called *bullae* around their necks. Circular or heart-shaped, the *bullae* could be made of leather or metal, sometimes even gold-plated, depending on the wealth of the family. When a boy came of age, he would dedicate his *bulla* at his household shrine and ceremonially don a *toga virilis* (of manhood) as a sign of entrance into Roman public life. Adolescents might also leave the trimmings from their first shave in their family *lararium* (as we saw in chapter 5 that Trimalchio had done). Images on finger-rings could likewise be intended to bring good fortune or serve an apotropaic (averting evil) function (fig. 42).

Certain symbols and practices were intended to protect against the Evil Eye—the malicious gaze and envy of

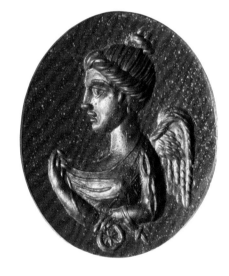

Figure 41
Pendant in the form of the forepart of a recumbent boar. Etruscan, 525–480 B.C. Amber, L: 2.5 cm (1 in.). JPGM, ACC. 76.AO.84.

Figure 42
Engraved gem with portrait bust of a winged Nemesis. Roman, second century A.D. Red jasper, 1.7 x 1.4 cm (¹¹⁄₁₆ x ⁹⁄₁₆ in.). JPGM, ACC. 84.AN.1.43.

Figure 43
Wall-painting of Priapus weighing his phallus against a bag of money. In the *fauces* (entrance hall) of the House of the Vettii (VI.15.1) in Pompeii. Roman, A.D. 1–79. Plaster and pigment.

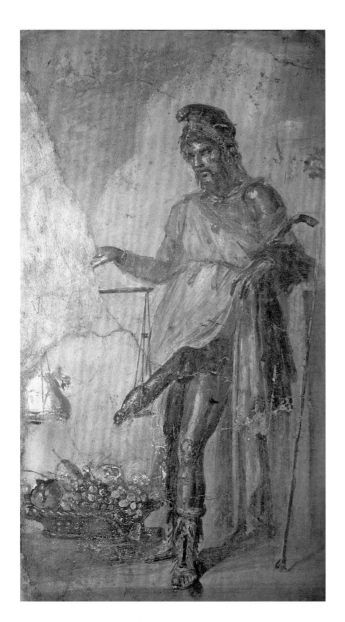

others that could harm or be deadly to one's person or property.[127] The threat of the Evil Eye could be diffused by the generative power of the male organ. As a symbol of fertility and prosperity, the phallus was regarded as apotropaic. Thus, phalli were worn as amulets and were displayed prominently at the entrances to homes and businesses. At the House of the Vettii at Pompeii, a colorful wall-painting of the fertility god Priapus weighing his huge erect phallus on a scale against a bag of money greeted visitors at the doorway (fig. 43). Comically large members or outrageous sexual behavior were intentionally depicted on wall-paintings and in mosaics (for example, in the bathhouse where one's naked body might incite envy) in order to provoke a humorous reaction, for laughter was likewise thought to dispel the Evil Eye.[128]

The remains of a victim of the eruption of Vesuvius was uncovered just outside the Nolan Gate of Pompeii.[129] The young girl had gathered together as many tokens of good fortune as she could before attempting her escape, all to no avail. In addition to a silver figurine of Isis-Fortuna, she had two amulets, one in the shape of a phallus and the other a crescent moon, and four finger-rings, one set with a chalcedony stone with an elegant depiction of Fortuna and another in the form of a snake with two heads.

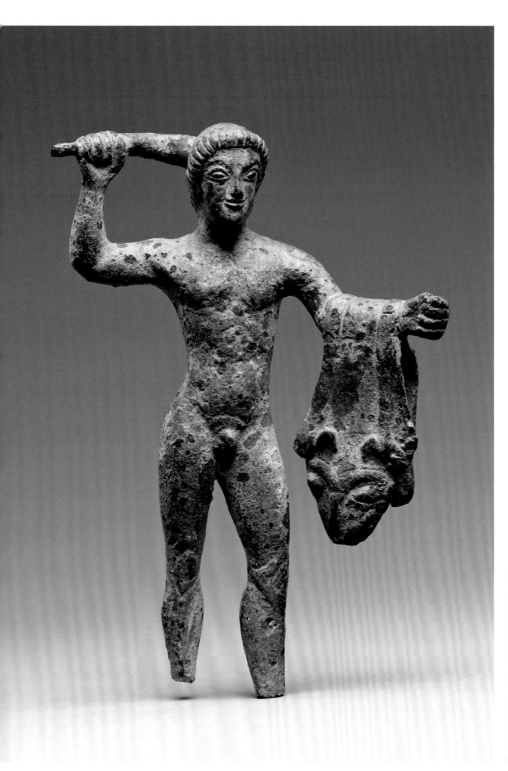

Figure 44
Statuette of the young
Hercules. Etruscan,
fifth century B.C.
Bronze, H: 12.2 cm
(4 ¾ in.). JPGM, acc.
71.AB.176.

Figure 45
Statuette of the old,
weary Hercules.
Roman, second century
A.D. Bone, H: 6.4 cm
(2 ½ in.). JPGM, acc.
88.AI.47.

The Hercules Phenomenon

Hundreds of small bronze figurines of the semidivine hero Hercules have been recovered from across Italy. Heracles to the Greeks and Hercle to the Etruscans, he had traveled across Italy (and most of the known world) in the course of his many Labors, and therefore dozens of communities claimed him as their shared founder—Herculaneum on the Bay of Naples among them. The figurines are the remains of a prolific cult among the Italic peoples.[130] Most are chance finds, pieces that have been picked up from unrecorded contexts outside archaeological excavations and have ended up in museums or on the art market, so they cannot be linked to a specific sanctuary or sacred area. However, the minimal information that we can trace about their probable findspots points to their presence scattered across the landscape. It seems likely that these statuettes were carried by Italic herdsmen, traders, and warriors as they traveled throughout different regions, especially in the mountains of the Apennines.

Already in the sixth century B.C. Hercules is found in Etruscan contexts on vase-paintings and temple decorations, often paired with his divine guardian, the goddess Athena. A complicated hero, Hercules was made to undertake

88 twelve Labors as punishment for killing his wife and children. He was admired for his superhuman strength and seen as a force of civilization, bringing order by defeating the beasts and enemies that terrorized communities. But Hercules was also portrayed as drunken, uncontrollable, and exhausted by his arduous Labors.[131] There are two main modes of representation for Hercules—either as a young, clean-shaven, and virile hero, or as an older bearded man with sagging muscles leaning on his club—the so-called Weary Hercules type. Occasionally he is shown holding a drinking cup or apples, the latter a reference to his eleventh Labor—fetching the golden apples from the Garden of the Hesperides, way out on the western edges of the world.

Dating to the fourth and third centuries B.C., the Italic bronze figurines of Hercules commonly represent him as a youthful warrior in assault mode: standing nude with his club resting on his shoulder and draped over the other arm a lionskin—a trophy from his first Labor, the killing of the Nemean lion (fig. 44). Due to his continual travels in the western Mediterranean, Hercules was associated with trade there and, because several of his mythical exploits involved herding livestock, with the tradition of transhumance—the seasonal migration of herds to different feeding grounds. Relatively light and portable, these bronzes may have been carried by shepherds or mercenaries as a source of comfort on the road and to seek protection from a favorite divinity, ultimately being left as an offering at a sanctuary.

Centuries later, Hercules formed part of the repertoire of deities venerated in domestic shrines. The hero can be part of a *lararium* wall-painting, as in the House of the Upper Storey in Pompeii, but more frequently statuettes of Hercules stand among the *Penates*.[132] A sensitive portrayal carved in bone reproduces the Weary Hercules type credited to the famed Hellenistic sculptor Lysippus (see chapter 4) (fig. 45). Because of its small size, this statuette could easily have served as a portable talisman.

Hermes and Mercury

As we saw in chapter 5, the fictional freedman Trimalchio's household shrine contained a large marble statuette of Venus. But Trimalchio's patron deity was Mercury. The god's role in the freedman's good fortune was celebrated in an elaborate wall-painting: "Then the painstaking artist had given a faithful picture of his whole career with explanations: how he had learned to keep accounts, and how at last he had been made steward. At the point where the

Figure 46
Statuette of Mercury. Gallo-Roman, A.D. 120–140. Bronze with silver and copper, H: 15 cm (5 ⅞ in.). JPGM, acc. 96.AB.199.

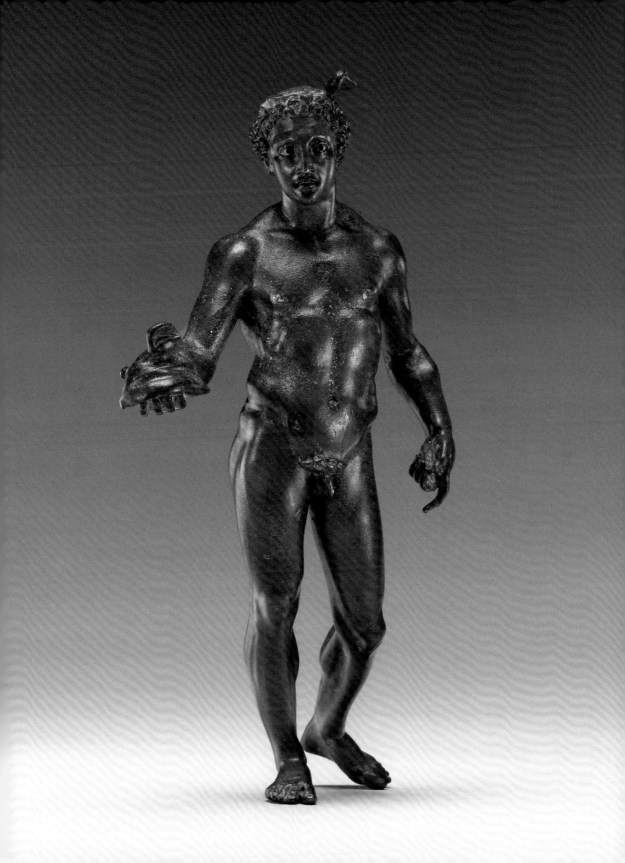

90 wall-space gave out, Mercury had taken him by the chin and was whirling him up to his high official throne. Fortuna stood by flowing with her horn of plenty" (Petron. *Sat.* 29).

Mercury was the Roman god of trade and wealth. He shared many characteristics of his Greek counterpart, the messenger god Hermes. A mischievous prankster, Hermes tricked and stole from the other gods and was associated with thieves. He was also the patron of travelers and accompanied souls to the borders of the Underworld. Like Hermes, Mercury was commonly depicted wearing winged sandals or a winged traveler's hat and holding the *caduceus* (herald's staff), but with the addition of a money bag (see fig. 3). Mercury was particularly popular in the Roman provinces, especially Gaul, where many bronze statuettes of the god have been found (fig. 46). A stunning hoard of silver drinking cups, plates, and statuettes dedicated to the god found at Berthouville in northern France is a testimony to the riches Mercury commanded.[133]

The Roman elite maintained a conflicted relationship with economic activity. Literary accounts idolize a life of *otium* (relaxation), but archaeological evidence is increasingly proving that the country villas of the elite were places of production. While *negotium* (business) was looked down upon and

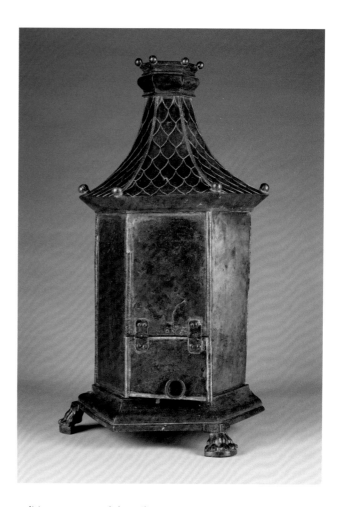

politics, oratory, and the military were considered suitable occupations for the upper classes, it is clear that banking, merchant shipping, and the ownership and exploitation of vast estates brought considerable wealth to the senatorial class. Freedmen, already outside the main social hierarchy, chose instead to celebrate their business talents and the industry and skills that had in many cases won them their freedom as well as brought them great fortune.

Figure 47
Offering box. Gallo-Roman, A.D. 130–180. Bronze, H: 51 cm (20 ⅛ in.). JPGM, acc. 95.AC.29.1.

Figure 48

Painted lararium embellished with stucco on a wall of the *caupona* (tavern) of Lucius Vetutius Placidus (I.8.8) on the Via dell'Abbondanza in Pompeii. The shrine faces the typical counter with *dolia* (sunken storage jars) for food and drink. Next to the shrine, a doorway leads through to a room for customers to sit. Roman, A.D. 1–79.

At the House of the Vettii visitors were confronted at the entrance by an image of Priapus; on the floor next to him is a huge basket of fruit, a symbol of abundance (see fig. 43). The freedmen owners of the luxurious house took pride in their wealth and wanted to show off their new social status. Indeed, money boxes may also have been placed in household shrines (fig. 47).[134]

The typical domestic shrine with wall-paintings of the *Lares* and *Genius* and space to set up the *Penates* that was found in Roman homes was also considered appropriate for shops, taverns, and guest houses, where it may have been used by the owners and staff or by customers.[135] Thus, the *caupona* (tavern) of Lucius Vetutius Placidus in Pompeii has a wall-painting framed by a miniature temple in shallow stucco relief at one end of a long U-shaped marble serving counter (fig. 48).[136] The *Genius* making an offering stands at the center, flanked by the *Lares* and, on the left, Mercury holding the *caduceus* and money bag and, on the right, Bacchus pouring wine into the mouth of a panther. Two snakes flank another altar painted below. Whether you were a gambler playing dice in a tavern or a business owner seeking the protection of his goods from thieves, in an uncertain world it was better to try to get the gods of luck and money on your side.

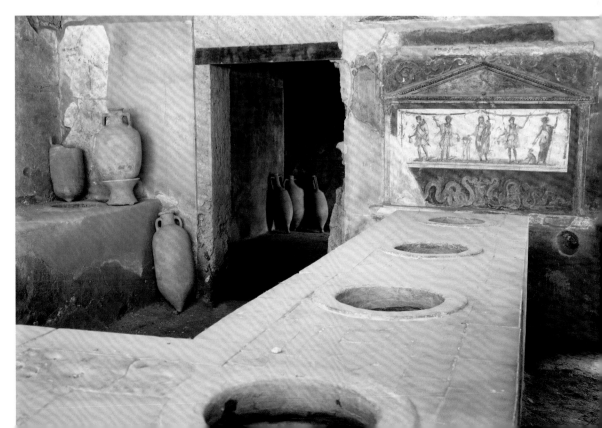

HEALTH MATTERS:

KITCHENS AND BATHROOMS

After this success she

inscribed on an offering:

"The wonder is not the size

of the plaque, but the act of

the god: Kleo bore a burden

in her stomach for five years,

until she slept here, and he

made her well."

—Inscription from the Sanctuary of Asclepius
at Epidaurus.[137]

On the corner of a city block in the center of Pompeii is a small tavern open to the street in front and connected by a door to the atrium of the house behind it.[138] The bar contains a typical built-in counter with spaces for large sunken storage vessels from which the proprietor would ladle out food and drink. Across the atrium, on the other side of the house, is the domestic service area. Here, down a narrow corridor leading to the toilets, was an unusual *lararium* (fig. 49).[139] The goddess Fortuna stands gracefully holding a golden cornucopia and steering the rudder of fate with a globe at her feet. On her head she wears a *modius*, a container used for measuring grain that symbolized a plentiful harvest. Next to her, a naked man squats on top of a platform, relieving himself. Two snakes, normally pictured in such shrines around an altar holding eggs or pinecones, instead rise up protectively on either side of him.

94

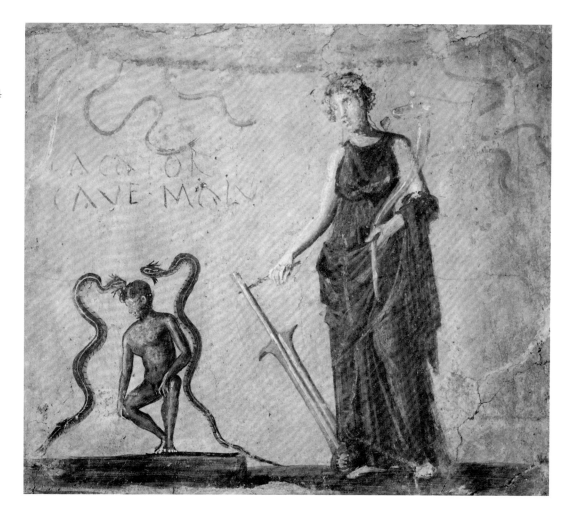

Cacator cave malum (crapper beware of evil) has been painted above his head. A small terracotta altar for offerings to Fortuna stood under the wall-painting. The house had another *lararium* in the atrium in the form of a miniature temple; this additional painted shrine at the back of the house was intended to ward off danger for those going to the toilet. Long before the first observation of bacteria, the Romans knew that there were risks in this most basic and mundane of activities, even if they did not understand the causes in our modern sense—lack of soap for hand-washing and perhaps use of a shared toilet sponge must have spread germs very quickly. Instead, the Romans largely viewed illness as something that could be prevented or cured with the good will and the help of the gods, especially the goddess Fortuna.[140]

Figure 49

Wall-painting with the goddess Fortuna facing a defecating man. From a house in Pompeii (IX.7.21–22). Roman, A.D. 1–79. Plaster and pigment. H: 68.7 cm (27 in.), W: 80.3 cm (31 ⅝ in.). Naples, Museo Archeologico Nazionale, inv. 112285.

In the Kitchen

Almost a third of the three hundred or so household shrines that have been uncovered and recorded from Pompeii and the Vesuvian cities are located in kitchens (followed in popularity by the atrium, the peristyle, and the garden; other areas account for less than ten percent).[141] The prevalence of these kitchen shrines may result from a symbolic association with Vesta and the *Penates* as deities of the hearth and larder. Indeed, along with the conventional depictions of the *Lares, Genius*, snakes, and altars, many kitchen shrines incorporate playful images of foodstuffs not found in more formal shrines beyond the kitchen area. Thus, a large wall-painting from a kitchen shrine in a villa on the slopes of Mount Vesuvius includes a boar's head, a ham, an eel, and pieces of meat speared on kebab sticks.[142]

These kitchen shrines may have been intended also to give slaves a place to worship within the household in an area appropriate to their station. The fact that some larger houses have more than one household shrine has led some scholars to suggest that the kitchen shrine was used exclusively or predominantly by slaves, and that shrines in the atrium or garden were used by the rest of the family.[143] Most kitchen shrines consist of wall-paintings alone, sometimes with niches for images of gods and trinkets; very rarely are

the niches decorated in the elaborate *aedicula* style found in other, more public areas of the house. However, it may be that there was a difference of occasion rather than status; certain rites involving various members of the household were celebrated at the shrine that was considered most appropriate. Houses with several shrines also raise the question of whether there were multiple sets of cult statuettes, one for each niche, or whether a single set was stored primarily in one shrine and moved around from room to room when needed.[144]

Finally, the location of kitchen shrines may be influenced by several practical factors. Kitchens provided the close proximity of water used for washing and purifying before making an offering, of the foodstuffs given as gifts, and of the means to prepare the meal after an animal sacrifice. In addition, there would have been ventilation for the cooking fumes, which would also have cleared the smoke from burning offerings and incense. For the same reasons of water supply and ventilation, the household toilets were often adjacent to, or within, the kitchen.[145] This was useful for plumbing and for keeping strong smells from other areas of the home, as well as for disposing of kitchen scraps directly into the drains.[146] But from the standpoint of health it was a disaster.

96 Kitchens must have been hot, smelly, cramped, and dangerous. Cooking was done on a stone-built raised cooking platform burning charcoal or wood, perhaps with a built-in oven area, using bronze and pottery vessels placed on iron tripods or directly on the flames. Most toilets were holes above a cesspit (or over a pipe down from the second storey of the house) with a wooden seat for comfort. Water for flushing was kept in pots in the latrine. At the House of Marcus Fabius Rufus in Pompeii, the toilet pit is directly next to the raised cooking platform—a surprisingly common occurrence, often with no partition between them.[147] It is likely that the master and mistress of the house often used chamber pots that were emptied by slaves, or slightly more pleasant garden latrines. The contents of cesspits were removed by slaves and sold as fertilizer.

Aware that these areas were potentially dangerous, but with no understanding of bacteria, Romans hoped that the close presence of the gods might keep the family and its slaves safe from disease. In one building at Pompeii, the niche for the household gods was set in a kitchen wall exactly between the cooking platform and the toilet.[148] An acknowledgment of the menace of an empty larder, kitchen shrines were also an attempt to mitigate the health hazards of improperly cooked and stored food and the spread of waste matter.

Asclepius and Hygeia

The Greek god of medicine was called Asclepius.[149] The son of Apollo, god of prophecy and music, and a mortal woman, Asclepius inherited the healing characteristics of his father. He was further trained in medical practice by the Centaur Chiron (who was also the tutor of the great hero Achilles). Although Asclepius was not one of the main twelve "Olympian" deities that formed the core of Greek religion, his cult was incredibly popular, and he came to be worshiped throughout the Mediterranean. Our earliest surviving reference to the god is in Homer's *Iliad*, where his sons Machaon and Podalirius are part of the Greek army (*Iliad* 2.729–32).[150] Machaon, called "son of Asclepius, the incomparable healer," treats King Menelaus, who has been struck by an arrow, cleaning the blood from the wound and placing an herbal ointment on it (*Iliad* 4.104–219). Later in the battle, Machaon is himself injured by an arrow grazing his shoulder. His comrades quickly remove him from the scene in a chariot because of the added value of his medical abilities: "For a healer is worth many other men for the cutting out of arrows and the sprinkling on of soothing herbs" (*Iliad* 11.514–15).

Interestingly, Asclepius is often referred to or depicted in conjunction

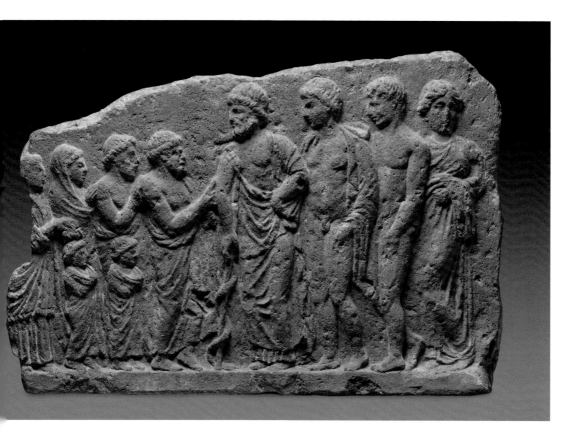

Figure 50
Relief showing a family
approaching Asclepius
and his family. Greek,
fourth century B.C.
Terracotta, 40 x 58 cm
(15 ¾ x 22 ⅞ in.). Oxford,
Ashmolean Museum, inv.
AN1984.111.

with his children, especially his daughter, Hygeia (literally, health), from whose name we derive the word *hygiene*. The identification of two of his sons as legendary doctors and his daughter as the divine personification of health may reflect the ancient perception of medicine as a family business wherein knowledge and skills were passed down through generations. A charming terracotta votive relief shows a family of suppliants approaching the central figure of Asclepius, who stands holding a staff (fig. 50). The parents with their children are mirrored by Asclepius's own sons

and daughter, who stand behind him: the mortal family encountering the divine family from whom they seek healing.

As in this relief, Asclepius's main attribute is a staff with a snake coiled around it. Occasionally the snake curls at his feet or around his person. In antiquity, serpents were associated with life, death, and regeneration as creatures that crawled into the ground—believed to be an access route to the Underworld and to chthonic deities. The snake was also closely connected with Asclepius's father, Apollo, who killed a python at his sacred oracular site at Delphi. Snakes

98

slithered freely around sanctuaries to Asclepius, where they were regarded as harmless and friendly and were imagined to cure individuals.[151] Extraordinarily potent and enduring, Asclepius's staff is still today employed as a symbol of medical practice; used in the logos of the World Health Organization and of the American Medical Association, among many others; on the sides of ambulances; and as an international emblem of a pharmacy.

Healing Visitations

Ill health is a universal source of pain and anguish to both the patients and their loved ones. A hymn to the goddess Hygeia, inscribed on a large stone found at the Sanctuary of Asclepius at Epidaurus in the Peloponnese, the god's main sanctuary, eloquently expresses a sentiment that many would agree still holds true today—the pleasures in life are worthless if not accompanied by good health:

Hygeia, of all gods honored by mortals, grant that I may dwell in thy company for the rest of my life and that thou remainest with me in thy graciousness. For if there is a possibility for man to enjoy wealth or children or royal power—a thing which makes man to be as a god—or love—after which we chase with the stealthy

nets of Aphrodite—, or if by the favor of the gods any other delight or at least any relief from misery has been revealed, then this (joy or delight) blossoms and shines with the song of the Graces only when thou art with us, blessed Health: no man is blessed without thee.[152]

In addition to cult buildings, Epidaurus contained a huge theater and a stadium for athletic and dramatic competitions (fig. 51).[153] Along with the temple of the god with an ivory-and-gold cult statue, there was a large *tholos* of uncertain function and a colonnaded

Figure 51
Reconstruction of the Sanctuary and Temple of Asclepius at Epidaurus, Greece.

building called the *abaton*. The *abaton* was a special space for worshipers to spend the night in the hope of being visited by the god in their sleep in a practice known as "incubation." Customarily during these sleepovers patients would dream that the god enacted some sort of procedure on them—such as opening their bodies to remove the cause of the complaint or applying a healing drug to the afflicted body part—and they would awake cured. The *abaton* and a consistent, fresh water supply were the two key features of sanctuaries to Asclepius.

An extraordinary collection of texts inscribed on stone blocks found at Epidaurus record the experiences of patients treated at the sanctuary.[154] Most patients were cured through incubation, but some were treated while awake by an animal (such as a snake or dog) licking the afflicted area or by having to react to a stimulus (a lame man suddenly ran after a boy who took his crutch).[155] These texts are vivid, graphic, deeply personal, and hugely affecting. The seventy or so tales preserved cover all manner of afflictions in succinct

accounts giving the name and home-
town of the individual, his or her illness
or injury, and the cure received:

Heraieos of Mytilene. This man had no hair
on his head, but plenty on his chin. Ashamed
because he was laughed at by the others, he
slept here. The god anointed his head with a
drug and made it have hair.

Euhippos bore a spearhead in his jaw for six
years. While he was sleeping here, the god drew
the spearhead from him and gave it to him in
his hands. When day came, he walked out well,
having the spearhead in his hands.

A man's toe was healed by a snake. He was in a
terrible condition from a malignant ulceration
on his toe. During the day he was carried out of
the abaton by the servants and was sitting on
a seat. He fell asleep there, and then a snake
came out of the abaton and healed the toe with
its tongue; and when it had done this it went
back into the abaton again. When the man
woke up, he was well and he said he had seen
a vision: it seemed to him that a good-looking
young man had sprinkled a drug over his toe.[156]

Most likely set up in the *abaton*, these
texts reassured patients of the likelihood
of a successful outcome of their visit.
Perhaps also visible to general visitors to
the sanctuary, the texts acted as adver-
tisements of the power of Asclepius.
Some directly refer to the recovery (or
punishment) of skeptics or those who

had failed to deliver their promised
votive offerings: "Hermon of Thasos. He
came as a blind man, and he was healed.
But afterward when he didn't bring the
offering, the god made him blind again.
Then he came back and slept here, and
he restored him to health."[157]

The practice of visiting a sanctuary
of Asclepius and trusting one's heal-
ing to the divine was not perceived as
contradictory to visiting a local doctor.
At least from the time of Hippocrates
(born around 460 B.C.), the father of
the healing profession, medical practice
was considered to be a craft with
specialized knowledge about drugs
and surgical interventions.[158] Doctors
recognized a causal role in disease and
afflictions that could be treated with
the appropriate method. However, the
profession emphasized its close ties
with its patron deity, Asclepius.[159] Galen
of Pergamum (A.D. 129–199), the most
famous doctor in antiquity, claimed
descent from the god, to whom later
stories also linked Hippocrates. As we
saw above, Asclepius's own sons were
characterized as mortal doctors, and
the god's treatments as described in the
votive texts include those performed by
physicians—drugs or surgery. Indeed,
doctors may have encouraged patients
to visit a sanctuary to Asclepius, rec-
ognizing the limits of their own ability
to effect a successful cure. Many of

the worshipers at the god's sanctuaries had chronic diseases or conditions, especially blindness, that could not be remedied by physicians. Moreover, some aspect of the healing powers of these sanctuaries may have resulted from the space for exercise, fresh air and water, and a chance for rest and recuperation provided within the sacred area.

Many, unwilling or unable to be treated by a doctor, turned to the divine for assistance. Healing sanctuaries were overflowing with votive offerings that crowded the pathways and areas around the temples and altars to the extent that we hear of cases where priests had to restrict the location of new statues and plaques. An inscription from the Sanctuary of Asclepius on the island of Rhodes forbid visitors to set up their dedications "in any other spot where votive offerings prevent people walking past."[160] In general, it was common practice for sanctuary officials to conduct ceremonies gathering together older dedications and burying the objects in pits within the sacred area of temples and shrines so as to make room for new ones.[161]

Anatomical Votives

101

Many of the offerings found in Greek healing sanctuaries are representations of body parts, which we term anatomical votives.[162] These were made of terracotta, wood, carved stone, or bronze, with more expensive versions in silver and gold.[163] Models of hands, feet, and lower legs are very common, as well as eyes and areas connected to childbirth and fertility such as breasts, uteri, and male genitals. Models of internal organs such as a heart, or intestines, or an opened chest cavity are rarer. Ears, noses, foreheads, and mouths are also found.

Generally assumed to represent the injured or diseased body part, anatomical votives were dedicated either in anticipation of divine healing or in thanks for a cure.[164] The woman who left silver and then later gold eyes at the Athenian Sanctuary of Asclepius may have been trying again with a more valuable offering after not recovering or may have returned cured of her affliction to leave another gift in deep gratitude.[165] Some anatomical votives are painted or sculpted to represent the wound or affliction and reflect contemporary medical knowledge. A well-known relief from Athens shows a dedicator carrying a large leg with a thick varicose vein to a healing shrine where some votive feet have already been deposited (fig. 52).[166]

102 In addition, hand and foot models may have represented prayer and the dedicator's physical presence at the place of worship, while eyes and ears could symbolize divine visions and a plea for the deity to listen.

Whether as a result of an existing independent tradition or of the influence of Greek practices, anatomical votives were enthusiastically embraced across Italy and are found in large numbers at Etruscan and Italic sanctuaries.[167] Perhaps some of the most striking are representations of a torso cut open to show the internal organs (fig. 53).[168] Although anatomical votives are recovered from sites that we know were associated with healing gods, they were also commonly dedicated to deities with little direct connection to healing, such as Hercules or Minerva, and at locations where it is unlikely that medical treatment was offered.

In 293 B.C., the cult of Asclepius was introduced to Rome. The Roman historian Livy recounts that envoys were sent to Asclepius's sanctuary at Epidaurus to seek assistance when the city was gripped by a terrible plague (*Hist.* 10.47, Summaries 11). The envoys obtained a snake from a temple and put it on board their ship, where the snake immediately curled itself around the ship's mast, which was deemed a good omen. As the ship entered the Tiber River, the snake slithered off and

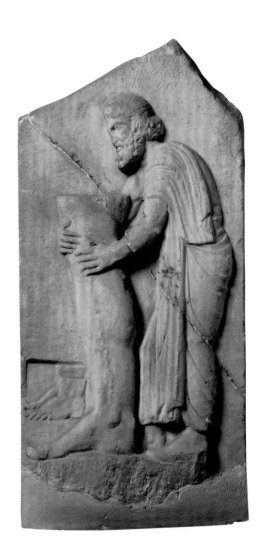

Figure 52
Relief showing a man carrying a leg with varicose veins as a votive offering. Greek (Athens), end of the fourth century B.C. Marble, H: 70 cm (27 ½ in.). Athens, National Archaeological Museum, inv. 3526.

Figure 53
Anatomical votive of a chest cavity. Etruscan, fourth century B.C. Terracotta, H: 21.6 cm (8 ½ in.). JPGM, acc. 73.AD.83.

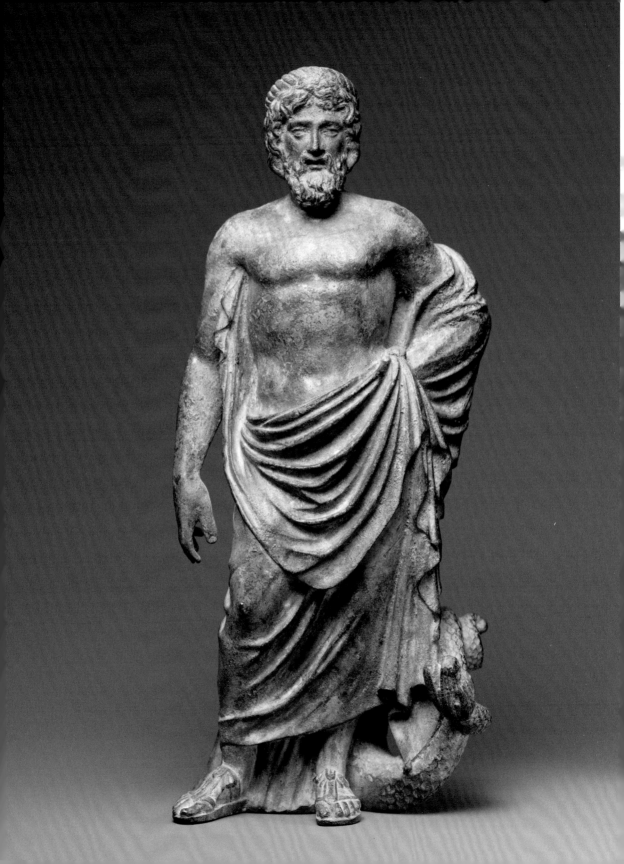

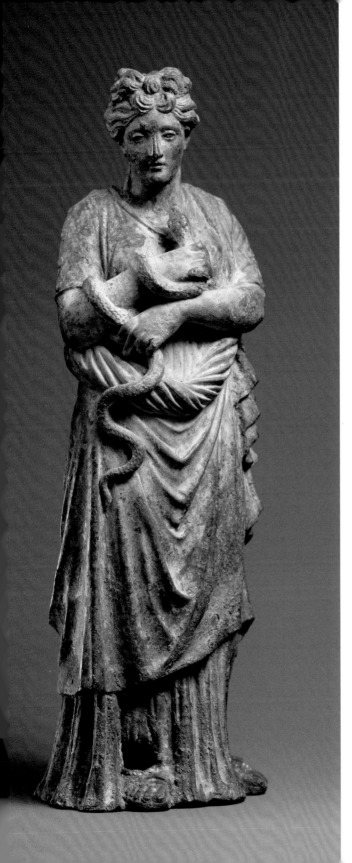

swam to the island in the middle of the river next to the city. They took that as a sign that Aesculapius (the Roman name for Asclepius) wanted his temple built on that island. The popularity of the Sanctuary of Aesculapius on Tiber Island is attested by the multitudes of anatomical votives that have been recovered from the site.

Asclepius and his daughter Hygeia were venerated also among the *Penates* in Roman domestic shrines (figs. 54 and 55). These figurines follow the standard iconography of the god and goddess found in larger cult statues; the bearded Asclepius, with a curled snake at his feet, is draped in a *himation* (cloak) that leaves his chest exposed, while the matronly dressed Hygeia holds a snake. In addition to the trust placed in the goddess Fortuna, statuettes of Asclepius and Hygeia embodied both the superior wisdom of Greek medical practice and the healing power of the divine to keep the household safe from sickness.

Figure 54
Statuette of Aesculapius.
Roman, first half of the
second century A.D.
Bronze, H: 16.5 cm
(6 ½ in.). JPGM, acc.
96.AB.195.1.

Figure 55
Statuette of Hygeia.
Roman, first half of the
second century A.D.
Bronze, H: 16.5 cm
(6 ½ in.). JPGM, acc.
96.AB.195.2.

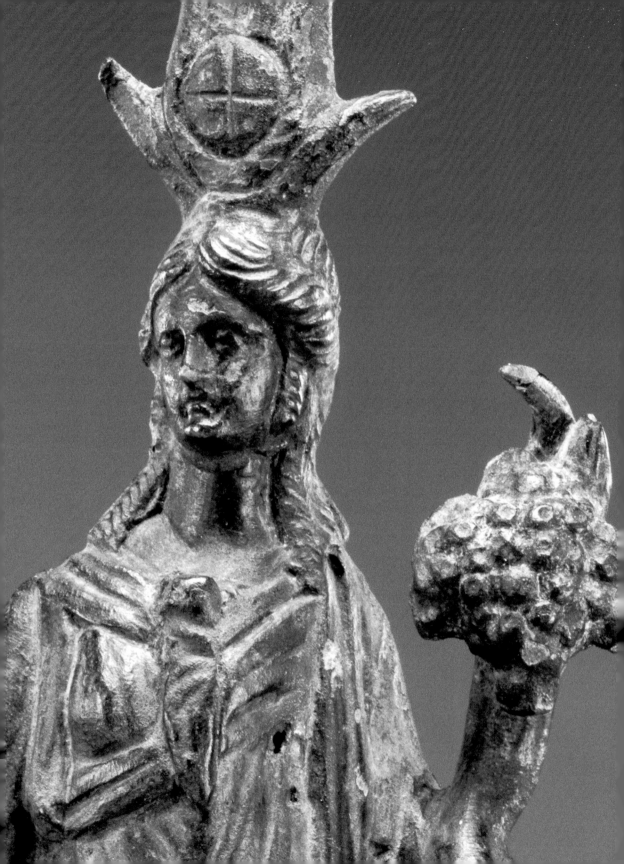

Nor do we think of the gods as different gods among different peoples, nor as barbarian gods and Greek gods, nor as southern and northern gods; but, just as the sun and the moon and the heavens and the earth and the sea are common to all, but are called by different names by different peoples, so ... there have arisen among different peoples, ... different honors and appellations.

—Plut. *Isis and Osiris* 67

In 31 B.C., Octavian defeated his rival Marcus Antonius and the last of the pharaohs, Cleopatra, in a naval battle at Actium off western Greece. This victory secured Octavian's position as ruler of the Roman state and paved the way for his confirmation as its first emperor, Augustus. Apart from the political revolution that this entailed, ushering in a period of imperial rule that would last in much the same form for the next four centuries, Rome was gripped by the drama of the Egyptian queen and her various lovers. Knowing after the lost battle that she was to be paraded as a conquest in a triumph at Rome, Cleopatra committed suicide to spare herself the indignity. As the Roman poet Horace writes:

She had . . . the courage to handle the sharp-
 toothed serpents,
letting her body drink in their black venom . . .

she would not be stripped of her royalty
and conveyed to face a jeering triumph.
(Hor. *Odes* 1.37)

Inspired by tales of Cleopatra's
extravagant lifestyle and facilitated by
newly created trading opportunities
when Egypt was annexed as a Roman
province in 30 B.C., the Egyptian mys-
tique stimulated a taste and desire for
Egyptian-crafted or -inspired artworks
across Roman Italy.[169] This Egyptomania
is seen in wall-paintings with landscapes
of the Nile, complete with crocodiles
and boats of pygmies; in table fur-
nishings; and in a fashion for pearls
introduced to Rome from Alexandria.[170]
Egyptian motifs add an exotic element
to Roman luxury domestic items, such
as an exquisite cameo-glass perfume
flask (fig. 56).[171] On the other side, a
young boy with a garland approaches
the Egyptian god Thoth in the form of
a baboon seated atop an altar, while
another boy moves toward an altar
decorated with a snake. Made in Rome,
this vase was produced around the time
when actual obelisks were being brought
to the city by Augustus as spoils from
Egypt and set up in public spaces.

In the second half of the first century
B.C., the cult of the Egyptian gods Isis
and Serapis (Osiris to the Egyptians)
soared in popularity, so much so that
Augustus ordered a series of restrictions

against their worship within the sacred
boundary of Rome in 28 and 21 B.C.[172] But
it would be the cult of the Persian sun
god Mithras that came to dominate pri-
vate devotion during the Roman Empire.

The *Evocatio*

Roman religion is renowned for its seemingly casual and comfortable integration of foreign deities. In the polytheistic environment, the attitude seems to have been "the more the merrier." Centuries earlier, the colonizing Greeks had looked for aspects of their own deities in the foreign gods they encountered or had attempted to join them together in complicated family trees. There was a tendency to equate the powers and spheres of influence, especially of major divinities—a strong female goddess; a great storm god; the king and queen of the gods; deities of love, fertility, and war—and to combine (or adopt) their respective attributes. In Italy, where the Greeks encountered Etruscan and Italic gods, the myth of the Trojan War and the wanderings of the Greeks returning home (or of fleeing Trojans, such as Aeneas) was used by both sides to connect and explain each other's ancestries and to create a common ground. Sanctuaries played an important role as places, literally, of sanctity, by providing a space perceived as neutral, protected, and therefore peaceful for trade and interaction. Alongside Odysseus, Diomedes, and the Dioscuri (Castor and Pollux, the twin sons of Zeus), the great hero Hercules had widespread appeal (as we have seen in chapter 6). Thus, in early Italy, the Roman pantheon emerged under the influence of its Greek and Etruscan equivalents.

However, there was an official process, known as the *evocatio* (summoning out), by which certain gods were incorporated into Roman state religion.[173] In the fourth century B.C., as Rome's ambitions grew beyond the confines of her small city, her military success began to force the surrounding peoples under her control. Rome's continued victory in battle was perceived as closely intertwined with her special, favored relationship with the gods. Just as the gods had ultimately decided that the Greeks would prevail over Troy, the most powerful deities were imagined to be on Rome's side. In the *evocatio*, the deity of an enemy city was invited before the battle took place to leave that city and join the Roman side. To encourage defection, the presiding Roman general would offer the deity a new home in a temple in Rome, with accompanying cult practices. The Roman historian Livy describes the *evocatio* of the goddess of the Etruscan city of Veii, Juno *Regina* (Juno in her aspect as queen of the gods), by the Roman general Camillus before he attacked the city in 396 B.C.:

Then the dictator [Camillus had been given special political powers], after taking the auspices, came forth and commanded the troops to

arm. "Under thy leadership," he cried, "Pythian Apollo, and inspired by thy will, I advance to destroy the city of Veii, and to thee I promise a tithe of its spoils. At the same time I beseech thee, Juno Regina, that dwellest now in Veii, to come with us, when we have gotten the victory, to our city—soon to be thine, too—that a temple meet for thy majesty may there receive thee.

(Livy *Hist.* 5.21)

Juno *Regina* must have been listening, for the Roman soldiers succeeded in conquering Veii, and a temple to the goddess was indeed built on the Aventine Hill in Rome.

Ensuring the continued good favor of the gods was the main preoccupation of Roman state religion. Colleges of priests and augurs were responsible for maintaining and interpreting communication with the divine by performing a series of carefully prescribed rituals and duties.[174] In the passage above, we are told that Camillus has taken the auspices before beginning the battle. The auspices—the practice of observing the sky for the presence or flight patterns of birds—were performed before battle or meetings of political assemblies and were part of the wider practice of divination (understanding the will of the gods) that was a fundamental element of official religious ritual. This also included interpreting dreams and omens, consulting oracles or oracular texts, and reading the entrails

of sacrificed animals.[175] Camillus further vowed an offering to Apollo to ensure his support.

Foreign deities were officially invited to Rome in times of natural disaster. Thus, as we saw in chapter 7, the Greek god of medicine, Asclepius, came to the city in 293 B.C. at the request of officials who went to see him at his sanctuary at Epidaurus because of a plague in Rome.

There was a considerable element of pragmatism in the Roman state's attitude of religious inclusion, or at least accommodation. As Rome's power grew, there was a tendency to permit a certain level of autonomy for conquered towns and cities, and local gods could stay in their home temples as they wished. As it happened, it was common for local elites with an eye on political power within the empire to pay homage to the traditional Roman pantheon, including worshiping the goddess Roma herself. Certainly, on the level of private devotion in the homes, it can be seen as a sensible attitude of live and let live. But our surviving sources inform us of incidences of conflict already in the Republican period, and first Judaism and later Christianity would push this accommodation to the limit under the emperors.

We saw in chapter 6 that magic and superstition were regarded as foolish, uncontrollable, and even dangerous, at least by the elite Roman males who

constitute our literary sources. Much of the general population would occasionally have carried out some sort of superstitious ritual or worn amulets for protection, just as today someone might carry a lucky charm on an airplane; and even a skeptic might balk at opening an umbrella indoors or might "touch wood" when tempting fate with an utterance. Similarly, cults that were perceived as too unusual, too secretive, too foreign, or simply too popular—especially with slaves, freedmen, and the lower classes—caused anxiety in official circles. In 186 B.C., an aggressive crackdown on the cult of Bacchus seems to have been motivated by a fear that the self-organization of groups of worshipers, and in particular the power of the leaders of these groups, could become a threat to the political establishment.[176] In the imperial biographer Suetonius's description of the actions of Emperor Tiberius (ruled A.D. 14–37), foreign religious practices are equated with the superstitions of astrologers: "He abolished foreign cults, especially the Egyptian and the Jewish rites, compelling all who were addicted to such superstitions to burn their religious vestments and all their paraphernalia. . . . He banished the astrologers as well, but pardoned such as begged for indulgence and promised to give up their art" (Suet. *Tib.* 36).

Among the senatorial elites, there was an intense distrust and derision of cults that were popular with women (imagine what your wife gets up to at secret women-only ceremonies where you are not allowed!) and of groups of worshipers gathering together unofficially, without control or oversight.

The Cult of Isis

Isis is in origin an Egyptian goddess, wife of her brother Osiris and mother of Horus—known as Harpocrates to the Greeks and Romans (fig. 57). Her cult dates back to the Pharaonic period, with the earliest evidence beginning in the Old Kingdom (2686–2134 B.C.).[177] The complex mythology of Isis, Osiris, and Horus centered around the murder of Osiris by his brother Set. Osiris was dismembered and his body parts scattered across Egypt. His heartbroken sister-wife Isis collected the pieces and conceived a child, Horus. Isis was therefore associated with mourning and funerary practices, and because pharaohs newly ascended to the throne were identified with Horus, she also played a role as protector of the pharaoh and his divine right to rule.

The Greeks encountered Egyptian gods as a result of lively trading ventures between the two regions. In the seventh

century B.C., Greeks from various city-states had established a joint trading post at Naucratis in the Nile Delta, exporting wine from Greece and importing linen cloth, papyrus, and highly prized Egyptian perfumes. During the fourth century B.C. the worship of Isis spread to Greece. A decree set up in Athens in 333/2 B.C. granting a group of Cypriots permission to purchase land to build a temple to Aphrodite informs us in passing that this is based on the precedent of a group Egyptians, who had already been allowed to construct a temple for their goddess Isis.[178] Isis was assimilated to the fertility goddess Demeter and could be called *Thesmophorus* (law giver, referring to the laws of how to work the land). This was traditionally an epithet of Demeter, whose gift to mankind of the knowledge of crop cultivation and organized farming was thought to lie at the foundation of a structured and orderly society. Isis was also connected to Artemis and Aphrodite. By the second century B.C., there was a large temple to Isis on Delos, a Greek island inhabited by a mixed trading community that included wealthy Italic merchants. Through these trading links with Greece and Egypt the cult came to Italy, where a temple for the goddess was erected at Pompeii in 80 B.C.

Archaeological evidence demonstrates the integration of Isis into both public and private worship across Italy and her

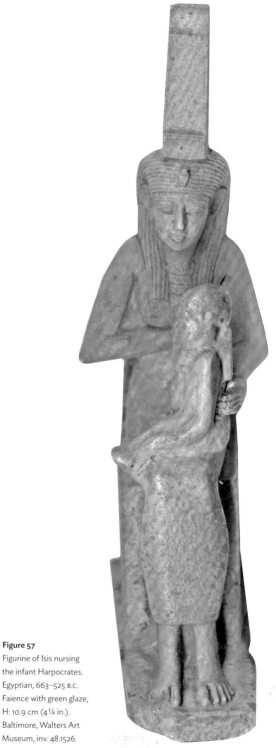

Figure 57
Figurine of Isis nursing the infant Harpocrates. Egyptian, 663–525 B.C. Faience with green glaze, H: 10.9 cm (4 ¼ in.). Baltimore, Walters Art Museum, inv. 48.1526.

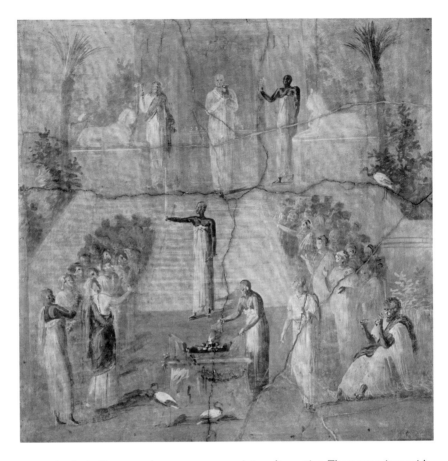

Figure 58
Wall-painting from
Herculaneum showing
a ceremony for Isis.
Roman, A.D. 50–75.
Plaster and pigment,
80 x 85 cm (31½ x
33½ in.). Naples,
Museo Archeologico
Nazionale, inv. 8924.

veneration by both men and women.
Pompeii and Herculaneum both had
temples of Isis, as did Rome, and a later
inscription from the port town of Ostia
attests to members of the senatorial
elite prominent in the cult there. On
a domestic level, two unusual frescos
preserved from Herculaneum, probably
originally from a private house, depict
the performance of rituals in honor
of Isis in front of a temple.[179] As the
veneration of Isis was a mystery cult and
initiates were sworn to secrecy, these
images provide an interesting glimpse

into cult practice. There are priests with
shaven heads, wearing robes tied in the
front in a typical "'Isis knot." One panel
shows worshipers being led in song (fig.
58), the other a figure dancing while
followers shake a rattle-like Egyptian
musical instrument called a sistrum that
was particularly associated with the
worship of Isis.

Some of our best evidence for the
worship of Isis comes from Plutarch, a
learned Greek member of the Roman
imperial court at the time of Emperors
Trajan and Hadrian (ruled A.D. 98–138).

114 Plutarch discusses the cult of the Egyptian gods in his essay *Isis and Osiris*. Although he presents the cult in a Greek framework, going as far as to claim that the name *Isis* derives from a Greek word, his account of their mythology and rituals seems to be relatively accurate.[180] Another useful source is the portrayal of the initiation of a certain Lucius into the mysteries of Isis in a novel by the Roman writer Apuleius (born about A.D. 125). The work, called the *Metamorphoses* (also known as *The Golden Ass*), is fiction, and we do not know if Apuleius was himself an initiate, nor indeed if there is an element of mockery in Lucius's passionate description. However, the text gives a vivid impression of the process of an initiation, including bathing and fasting for purification, receiving a special garment, experiencing a revelation, and celebrating a newfound understanding of and devotion to the goddess. In general, initiates to mystery cults were thought to experience a deeper, more personal connection to the divine and were promised a happier afterlife in a preferred area of the Underworld. Lucius describes his revelatory experience thus: "I came to the boundary of death . . . I traveled through all the elements and returned. In the middle of the night I saw the sun flashing with a bright light. I came face to face with the gods below and the gods above and paid reverence to them from close at hand" (Apul. *Met.* 11.23).

Plutarch describes Isis as disclosing her divine mysteries to those who truly and justly have the name of "bearers of the sacred vessels" and "wearers of the sacred robes," indicating the importance of the special trappings of the cult that are shown in the wall-paintings from Herculaneum.[181] In both Plutarch's and Apuleius's descriptions, Isis is omnipotent, embodying elements of many other deities. She is a mother and savior goddess, protecting the vulnerable and the poor, and safeguarding agricultural fertility and seafaring. A fascinating hymn in praise of Isis was found inscribed in Greek in a sanctuary to Isis at the city of Cyme in Asia Minor dating to the second century A.D. Based on an earlier Egyptian version inscribed on a stone block in front of the Temple of Ptah (Hephaestus) at Memphis, the hymn lists her many accomplishments: "I established laws for humans. . . . I am she who invented crops for humans. . . . I invented fishing and seafaring. . . . I am mistress of rivers, winds, and sea. . . . I am mistress of war. I am mistress of the thunderbolt. I calm and agitate the sea. I am in the rays of the sun. . . . I free those in chains. . . . To me fate listens."

In the House of the Gilded Cupids at Pompeii, a shrine dedicated to Egyptian deities was found in a corner of the peristyle.[182] The wall-paintings depict Isis, Harpocrates, Serapis, and cultic symbols

Figure 59
Statuette of Isis-Fortuna. Roman, second century A.D. Bronze, H: 19 cm (7 ½ in.). JPGM, acc. 71.AB.180.

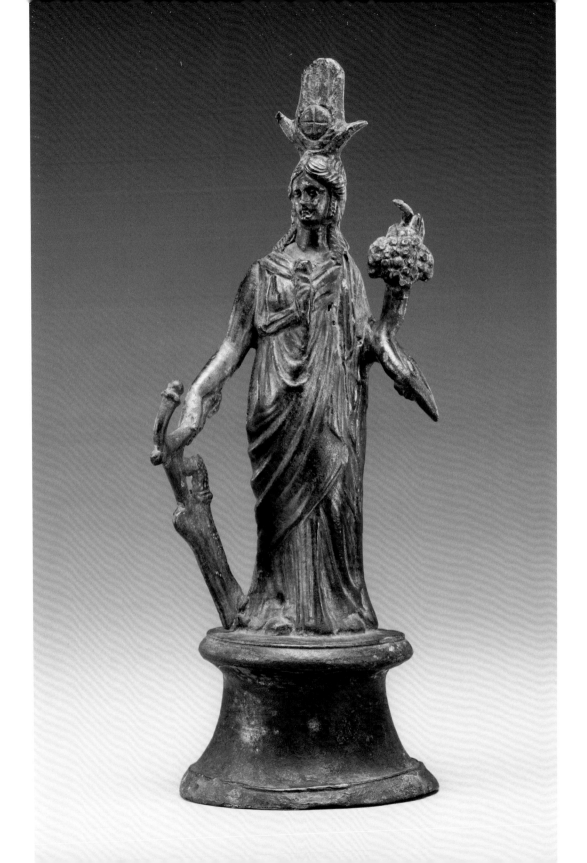

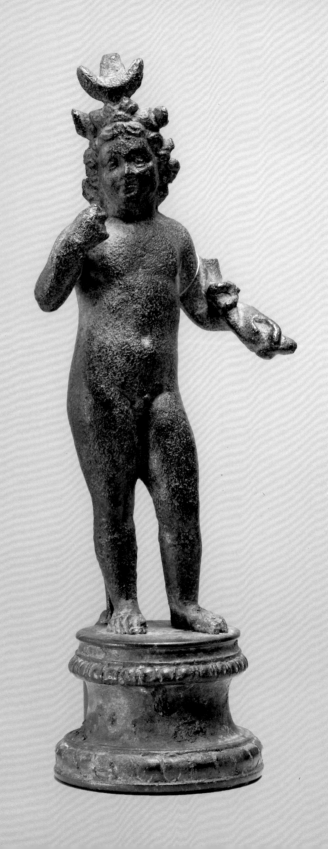

Figure 60
Statuette of Harpocrates.
Roman, second century
A.D. Bronze, H: 16 cm
(6 ¼ in.). JPGM, ACC.
73.AB.152.

Figure 61
Panels portraying Isis,
an unknown man, and
Serapis (Egyptian Osiris).
Romano-Egyptian,
25 B.C.– A.D. 50 (gods)
and about A.D. 100
(man). Tempera on
wood, H: 19.1 cm
(7 ½ in.). JPGM, ACC.
74.AP.20–22.

such as the *uraeus* (sacred coiled snake);
nearby were found a marble figurine of
Isis seated on a throne and a terracotta
oil lamp with Isis, Harpocrates, and an
animal-headed Egyptian deity.

However, figurines of Isis and
Harpocrates were not just placed in
domestic shrines with a specifically
Egyptian aspect. Rather, they occur
frequently among the eclectic choices of
deities that make up the *Penates* of most
lararia. Depictions of Isis in combina-
tion with the goddess Fortuna were
particularly popular, and many of these
statuettes are preserved. Isis-Fortuna is
conventionally depicted in a matronly
dress, steering a rudder in her right hand
and holding a cornucopia with her left
arm (fig. 59; see also fig. 49). Her dis-
tinctive headdress is made up of a lunar
disk between the coiled *uraeus* and the
horns of Hathor (goddess of love and

motherhood represented in the form of
a horned cow).

Other figurines show Isis seated on
a throne holding or nursing her son,
Horus/Harpocrates, a type that goes
back to Pharaonic times. Under the
Ptolemaic dynasty ruling Egypt, Osiris
and Horus had been given makeovers
to make them more accessible to the
Graeco-Roman audience by eliminating
their animal features. The new versions,
Serapis and Harpocrates, blended
aspects of Egyptian and Greek gods.
Harpocrates was identified with Apollo
and the Sun and, like Eros, was depicted
as a child (fig. 60). Serapis embodied
characteristics of Hades, Asclepius,
and Dionysus and was represented as
a bearded man with a *modius* on his
head. Painted wooden panels of Isis and
Serapis flanking an unknown man were
probably assembled as a triptych to serve

118 as a portable household shrine (fig. 61). Made in Egypt between 100 B.C. and A.D. 100, it reflects both the extraordinary continuity and the radical change over the preceding millennia in the cult of Isis (and her husband Osiris, now known by a different name and with a different iconography). Isis wears an elaborate headdress with the *uraeus*, her mantle is tied in the typical knot, and she carries a staff and a wreath of pink flowers. Sheaves of grain around Serapis, along with the customary *modius*, are additional symbols of his role as an agricultural deity. Instead of Harpocrates, the central panel shows an ordinary individual. He holds a sprig and a wreath of pink flowers, symbols of rebirth, suggesting that he might be an initiate into the mysteries. This central panel is very similar in style and technique to contemporary mummy portraits, raising the possibility that it depicted a deceased member of the household.

The Cult of Mithras

As we started this chapter with a military victory, so we return to the Roman army to conclude. For hundreds of years, the Roman army marched across Europe and western Asia, securing outposts, from the damp cold stones of Hadrian's Wall in Britain to the flat dusty plains of Dura-Europos on the eastern edges of

present-day Syria. Because the soldiers often found themselves in hostile surroundings and separated from their families for long periods, it is not surprising that we find evidence of private religious sentiment among them, alongside the official military rituals that reinforced communal moral.

Thought to have originated in Persia, the cult of *Sol invictus Mithras* (the unconquered sun god Mithras) spread through the Roman world from A.D. 100 onward and became hugely popular, particularly with the army.[183] Because it was a mystery cult, like that of Isis, there is a great deal that we do not know or understand about it. Worship of Mithras took place indoors, in dark torch-lit rooms. Mithraea—places for the worship of Mithras—uncovered in Britain, Germany, and Italy are broadly similar: windowless, narrow rectangular buildings, sometimes partially underground or in caves, with space for dining along the long walls and a focal scene of Mithras painted or in relief sculpture in a shrine facing the entrance. The distinctive principal image of the god (called the *Tauroctony*) shows him with a Persian hat and billowing cape, wrestling and plunging a sword into the neck of a bull (figs. 62 a–b). Sometimes he is surrounded by symbols of the zodiac or representations of the planets; it is clear that astrology was an important part of

Figures 62 a–b
The shrine from the Mithraeum at Dura-Europos (Syria) contains two *tauroctony* reliefs, set one above the other, dedicated by different military officers a few years apart.

Upper relief: Mithras slays the bull under an arch decorated with the signs of the Zodiac. Figures of the dedicator, named Zenobius by a Greek inscription, and presumably his family members are squeezed in to the right. A.D. 170. Limestone, 76 x 106 cm (29 7/8 x 41 3/4 in.). New Haven, Yale University Art Gallery, Dura-Europos Collection, inv. 1935.98.

Lower relief: Mithras kneels to slay the bull, with a dog jumping up on the right. Above his head are a star in a crescent moon, a flying crow, and a sun disk. Inscriptions in Palmyrene and Greek name the dedicator, Ethpeni, an officer in the army. A.D. 168. Limestone, 41.4 x 56.3 cm (16 1/4 x 22 1/8 in.). New Haven, Yale University Art Gallery, Dura-Europos Collection, inv. 1935.97.

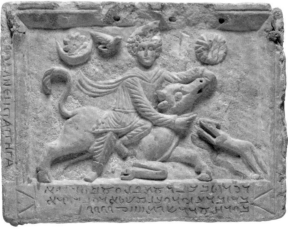

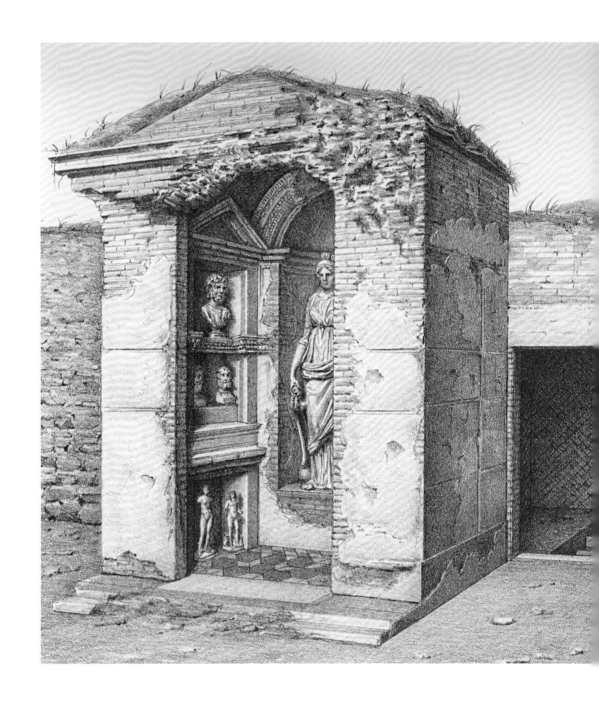

the cult, but the exact meaning remains largely enigmatic.

We do know that the cult of Mithras was open only to men. Moreover, judging by the small size of excavated Mithraea, it seems to have been practiced in restricted groups of around forty or fewer participants, and a single town could have many Mithraea to accommodate followers (Ostia had more than a dozen). Initiation rites seem have involved submitting the initiate to certain situations of fear and physical torture. A mosaic floor from a Mithraeum at Ostia is decorated with the seven stages of initiation into the cult—each titled after an animal, such as Raven or Lion, or a human figure, Bridegroom, Sun-runner—that members progressed through on their path to enlightenment. One of these stages was that of Soldier, a nod to the occupation of many of the adherents of the cult. Graffiti painted onto the walls of a Mithraeum at Rome corroborate these stages, exuberantly welcoming new members to the various levels: "Hail to the Sun-runners under the protection

of the Sun. . . . Hail to the Lions under the protection of Jupiter. Hail to the Soldiers under the protection of Mars."[184] Practiced by men at all levels of society, including military and administrative officials, and even associated with the emperor in the late third century A.D., the cult of Mithras was not a fringe sect. Rather, it had broad appeal, for it offered initiates a strong sense of belonging and community and an astrological explanation for their place in the cosmos.

In the gardens of a house dating to the end of the third century A.D. on the Esquiline Hill in Rome a large domestic shrine was uncovered in the form of a small building with niches for statuettes and busts.[185] At the back stood a near life-size marble sculpture of Isis-Fortuna, while to the side shelves held a bust of Serapis and figurines of Venus and Hercules, among others, herms, and oil lamps. Interestingly, directly next to the shrine were found stairs leading down to a Mithraeum (fig. 63). This juxtaposition of Isis and Mithras encapsulates the cultic environment of the third century A.D. The owner of the house had a range of religious options at his disposal, beyond the traditional Roman pantheon. The popularity of these alternative modes of belief would fundamentally change the nature and meaning of Roman private devotion and individual relationship with the divine.

Figure 63
Drawing of a shrine with an Isis statue next to a Mithraeum, from the Esquiline Hill in Rome. First published in the *Bullettino della commissione archeologica comunale di Roma*, 1885. "Del larario e del mitreo scoperti nell' Esquilino presso la chiesa di san Martino ai monti," pl. 3. GRI N5760.B93.

> *No person of any class,*
> *. . . whether he holds a position*
> *of power, . . . whether he is*
> *powerful by chance of birth*
> *or lowly in family . . . shall*
> *in any place whatsoever . . .*
> *slaughter an innocent victim*
> *to insensate images; nor*
> *shall he venerate by a more*
> *secret sacrifice his* Lar, *. . . his*
> Genius, *. . . or his* Penates,
> *. . . nor shall he light candles,*
> *burn incense, or hang up*
> *garlands for them.*
>
> —*Theodosian Code* 16.10.12 (A.D. 429–438)

On 8 November A.D. 392, Emperor Theodosius II issued an edict outlawing pagan rituals.[186] Generally concerned with animal sacrifice, the edict specifically targeted the "more secret" sacrifices and offerings made to household gods. The following year the Olympian Games were halted on imperial orders. A bronze plaque from the Sanctuary of Zeus at Olympia lists the names of winners of the games from the first century B.C. until A.D. 385, our latest surviving record.[187] The relationship between sporting competition and the pagan gods was too direct—honoring the Graeco-Roman deities was too integral a part of the purpose and spectacle of the games and the training and skill of the athletes—to be allowed to continue under the new Christian order.

At the turn of the fifth century A.D., the religious landscape of the Mediterranean was very different from where we started

124 this book, a good millennium earlier, with the story of the hearth goddess Hestia in the *Homeric Hymn to Aphrodite*, around the time when the first Olympian Games were held, in 776 B.C. Progressing from a gradual change in the early Imperial period with the rise in popularity of sects outside of the main pantheon—such as the cult of Mithras and Christianity—the conversion to the latter by Emperor Constantine in A.D. 312 heralded a radical shift.[188] The vast Roman Empire was by then divided into an eastern and a western half, with centers of power rivaling Rome at Nicomedia and Antioch (both in modern Turkey) and two senior and two junior emperors sharing rule. When Constantine marched on Rome in 312 and defeated the western ruler, Maxentius, he credited his victory to the divine will of the Christian god. Before the Battle of the Milvian Bridge outside the city, Constantine saw a vision of a cross in the sky with the text "conquer by this symbol," and Christ visited him in a dream. As a result of these surprising omens and his decisive victory, Constantine turned to favor Christian beliefs over pagan practices. Unifying the empire again and constructing the new capital of Constantinople in the east, Constantine declined to perform public sacrifices and, perhaps most importantly, began the construction of

churches in Rome and across the empire.

However, as we can see from the Theodosian Code quoted above, much had remained remarkably unchanged. Animal sacrifices were still being performed in the same manner as they had been for the past millennium. Images of the gods were venerated with libations of wine, garlands, and incense, and the worship of the *Lares, Penates,* and *Genius* persisted. It had proved difficult to eradicate the traditional practices of the populace. In a complete reversal from earlier attitudes, the established religion was now the monotheistic Christianity, and the old ways of venerating the gods were viewed as superstition. Moreover, Christianity offered a different sort of relationship with the divine. Based on texts and teachings with a fundamental focus on prayer and faith, it was in essence a private religion as well as an official one. Private devotion came under scrutiny and criticism, in contrast to the earlier more flexible attitude about which deities an individual or a household venerated. Thus Theodosius's collection of imperial laws goes on to stipulate that anyone worshiping in the traditional ways at home "shall be found guilty of violating *religio* and have confiscated that house or property in which it is established that he served a pagan *superstitio*."

Figure 64
Interior of the the synagogue at Dura-Europos (Syria). A series of wall-paintings in four registers depict episodes from Jewish history, such as the Exodus, Jerusalem and the Temple of Solomon, and the Battle of Ebenezer, with the Torah shrine in the center.

A Christian House-Church from Dura-Europos

The remarkably well-preserved archaeological remains from the Roman military town of Dura-Europos offer a view of the practicalities of religious accommodation and coexistence from the mid-second to the mid-third century A.D. Located on the Euphrates River, Dura-Europos controlled trade routes between the Parthian Empire to the east and the Mediterranean to the west. Founded around 300 B.C. by the

Seleucids, the town was in and out of Parthian control before it was finally conquered by the Romans in A.D. 165. On the edges of the eastern Roman Empire, in present-day Syria, a Roman garrison was stationed there in a large military camp until it was conquered around A.D. 256 by the Sassanians (an Iranian dynasty, A.D. 224–651) and abandoned.

Dura-Europos was a cultural and religious melting pot of Greek, Eastern, and Roman customs, whose inhabitants practiced many different types

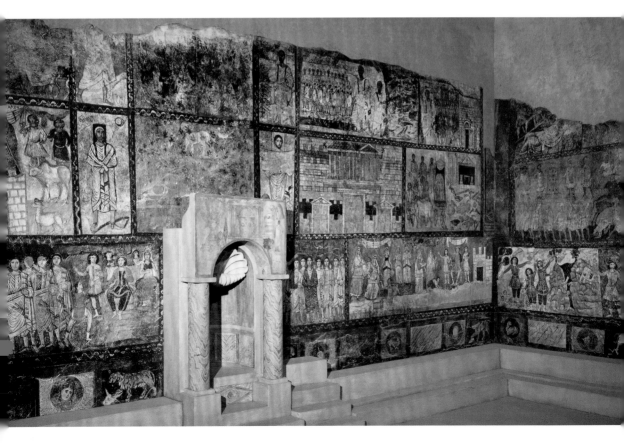

of worship. The site included a temple to Greek Artemis and Adonis, and one to Bel, a god imported from the nearby Syrian city of Palmyra. Along the edge of the city walls near the main gate, a Mithraeum (see chapter 8), a synagogue, and a Christian house-church stood in close proximity to one another.[189]

Early Christian gatherings usually took place in so-called house-churches, residential buildings that were architecturally converted or merely designated as places of congregation.[190] This was partly due to fear of persecution, but it was also a natural extension of the function of the Roman house as a place to hold public meetings, conduct business, and perform religious ceremonies for the household and for the wider community.

The house-church at Dura-Europos is our only surviving example anywhere from before the fourth century. It suggests that most early Christian places of worship were unmodified homes supplied with the furniture and objects necessary for devotion. A conventional two-story house built around a central courtyard, the house-church was converted by joining two smaller rooms to form a large rectangular hall for meeting and dining and turning another room into a baptistery by constructing a basin at one end.

Interestingly, all three buildings—the Mithraeum, the house-church, and the synagogue—were decorated with elaborate, similar-style wall-paintings, which are very unusual for the latter, for figural decoration was prohibited in the Jewish faith (fig. 64; see also figs. 62a–b).[191] The wall-paintings of the baptistery of the Christian house-church are very poorly preserved, but they featured a somewhat eclectic assortment of depictions of Christ as the Good Shepherd, Adam and Eve, the miracles of Christ, and David and Goliath. The synagogue is decorated with a staggering array of figures in multiple registers, including scenes of the Exodus, Moses, and the Battle of Ebenezer, as well as a depiction of the Temple of Solomon at Jerusalem. The arch of the torah shrine is decorated with a painting of the Temple flanked by items of Jewish cult, such as a menorah and palm branch, and Abraham's sacrifice of Isaac.

These wall-paintings from religious buildings in Dura-Europos reflect empirewide trends in artistic representation of the third century A.D. But they also exhibit a distinctive local style that was evidently thought appropriate for very diverse places of worship. Whether directly competing for adherents or peacefully co-existing, the Mithraeum, the synagogue, and the house-church, all located along the same stretch of city wall, chose similar decorative schemes, which created a familiar environment for

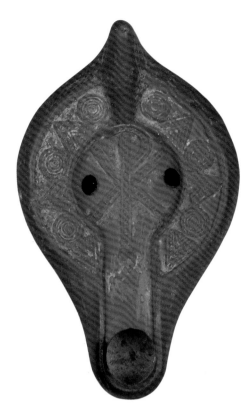

of the mother and child to the portrait heads of saints.[192] The fabric of daily life was slow to change; Christian symbols only gradually replaced the old deities on objects from tombstones to oil lamps (fig. 65). The sharing of food, the flickering of a lamp flame, the perfuming smell of incense, and communication through prayers and hymns remained integral parts of the new religious order.

The use of votive objects also continued.[193] In the medieval period, wax models, particularly of hands, feet, and other body parts—just like ancient anatomical votives—were left at shrines and churches in gratitude for the healing powers of a saint.[194] As intermediaries of the divine, these saints could perform miracles, and their physical personage was imbued with religious power. Parts of their clothing and possessions and their flesh, bones, hair, and even blood were valued and preserved as conduits of this power. Known as relics, these remains were stored in specially fashioned reliquaries placed on altars and in shrines and became objects of veneration that could heal and succor the faithful.[195] The reliquaries were often very ornate and richly decorated. Wood from the Cross and objects touched by Christ, the Apostles, or the Virgin Mary were particularly holy, and the most famous relics brought prestige and visitors to the place that possessed them.

Figure 65
Moldmade oil lamp with a beaded chi-rho (Chr[ist]) on the discus. From North Africa, mid-fifth to mid-sixth century A.D. Terracotta, L: 14.4 cm (5 ⅝ in.). JPGM, acc. 83.AQ.377.269.

their members. While on a political and philosophical level monumental shifts in policy and thinking were taking place across the empire, the evidence from places such as Dura-Europos suggests that the preferences and practices of individuals and communities maintained elements of continuity.

The fourth century A.D. saw a protracted period of debate and conflict over what it meant to be Roman and what it meant to be Christian. The boundaries were fluid and variable, and many aspects of the iconography of the new religion were adopted and adapted from the pagan tradition, from the image

128 For medieval worshipers, the journey to visit holy people and places became of paramount importance as a test of endurance and a manifestation of faith. Hundreds of thousands of people followed established routes of pilgrimage across Europe and the Near East. Lead badges known as pilgrim badges decorated with images of the church, site, or saint were sold at the destination and worn by pilgrims as symbols of their journey. Moldmade and mass produced, these badges were an inexpensive and portable souvenir of a personal religious experience.

Church officials struggled to police superstition and magic, but intense personal devotion to martyrs, and later to the Virgin Mary or certain saints, by individuals and communities proved impossible to curb. These figures continued to be venerated in shrines inside churches and homes with prayers for help or of thanks, and with flowers, tokens, and candles in much the same way as in the ancient pagan rites. A modern shrine from Crete constructed in the shape of a miniature church is strongly reminiscent of the miniature temple-shaped *aediculae* found at Pompeii and Herculaneum (figs. 66 a–b).

Indeed, due to the importance of conversion and the active spread of Christianity across the world, some elements of accommodation to local pre-existing customs and practices were

necessary, even encouraged. In 1531 in what is now Mexico, when the Madonna visited an indigenous peasant called Juan Diego, an image of her appeared on his cloak. Known as Our Lady of Guadalupe, this miraculous image became a powerful icon, seen to bring together the native and colonial communities, and a source of strength and identity for Mexican worshipers. Today the Basilica of Our Lady of Guadalupe in Mexico City, which holds the cloak, is one of the world's most visited sacred sites. As a particular iteration of the Madonna, Our Lady of Guadalupe is rooted in local mythology, just as Artemis of Ephesus was depicted in a distinctive form, immediately recognizable, that connected her to Ephesus, while her worship spread beyond her home city. Across Mexico, there are hundreds of shrines to the Virgin Mary that have specific local significance.

As in antiquity, other elements of accommodation were necessary due to oppression. In a strikingly similar vein to the Christian house-church in Dura-Europos, a Catholic house-church built in 1663 is preserved within the top three stories of a canal house in Amsterdam that from the outside appears to be an ordinary dwelling.[196] When a group of northern European territories, including the northern Netherlands, declared independence from the Spanish King Philip II in 1581, Calvinism became the

dominant religion, and Catholic worship was forbidden. However, for the next two centuries, Catholicism was practiced clandestinely in homes and private spaces with the tacit tolerance of the authorities. In the Amsterdam house-church, called Our Lord in the Attic, a large three-story space is hollowed out within the house to contain the altar, pews, and two upper balconies.

Modern Shrines in the Home

Sustaining a personal connection with the divine in one's home (or place of work) is an important aspect of many modern religious practices. Both Japanese and Chinese religions customarily involve domestic worship. Traditional Chinese practices incorporating Taoist, Confucian, and Buddhist teachings center around the rites of passage: birth, marriage, and death.[197] Households may contain shrines for the ancestors of the family and patron spirits at which food and other offerings are left to appease the deities (fig. 67).

In the Shinto tradition in Japan, the *kami* are regarded as divinities of ancestors, place, nature, communities, and the imperial household in a way that can be thought of as similar to the ancient conception of the *Lares*.[198] Conventionally, homes have both a *kami* altar (*kamidana*) to ensure good favor for the household and a Buddha altar (*butsudan*) at which

Figures 66 a–b
Small shrine in Anissaras, Crete, in the typical shape of an Orthodox Greek church. Inside, a candle illuminates icons of Christ and the Virgin Mary. Found across the Greek countryside, most of these shrines memorialize lives lost at that location.

the deceased ancestors of the family
are venerated. The *butsudan* is con-
nected to worship of the emperor, and
to safe-guarding the state in general
and the local Buddhist temple, again
in a manner similar to how the ancient
Genius was equated with the *Genius* of
the emperor and the perpetuation of the
Roman state. In Japan, worship is over-
seen by the (generally male) head of the
household, but women and children also
care for the family's altars. Both types of
altars display images, trinkets, Buddhist
icons, and memorial tablets for departed
relatives; liquid and food offerings,
incense, flowers, and candles are placed
on these altars.

In the polytheistic Hindu faith,
domestic shrines are at the heart of
the home, and personal interaction
with one's favored divinity is of great
importance.[199] A purified space is set
aside for worship. As with the Roman
lararium, Hindu domestic shrines can
range from modest displays of religious
images to ornately decorated niches
and stands in the form of miniature
temples for figurines (fig. 68). Members
of the household are encouraged to
choose a deity to venerate with whom
they feel a particular connection. Thus,
a home may contain multiple shrines
to cater to individual preferences, or
a single shrine may house images and

Figure 67
Shrine from Malay
Chinese home show-
ing candles burning,
incense sticks, and
offerings of fruit.

Figure 68
Hindu domestic shrine
with divine images
bedecked with garlands
of flowers.

icons of various deities. Daily venera-
tion includes making offerings, laying
garlands of flowers, lighting oil lamps,
burning incense, prayer, singing, and the
recitation of mantras.

Of course, this does not imply that
these modern practices are somehow
derived from the customs of the ancient
Greeks and Romans; rather, they are
based on long-standing traditions in
other parts of the world. However,
there do seem to be elements of man's
relationship to and interactions with
the divine that have had universal
relevance for millennia and continue to
have so today. In addition, adherents of
contemporary pagan beliefs deliberately
follow ancient precedents. Twenty-
first-century pagans may have domestic
shrines containing images of ancient
deities such as Artemis or Isis.

Memorialization and Belief

Our word *shrine* encompasses more than
a strictly religious connotation as a space
housing a deity or sacred individual and
can refer to the public memorials that
form in a location of tragedy and death.
These memorials of photographs, cards,
flowers, and gifts range from small road-
side shrines commemorating accident
victims to the huge outpourings of grief

132 that sometimes follow an act of terrorism, a natural disaster, or the death of a public figure—such as that of Princess Diana in 1997. In times of sadness, people are drawn to connect with each other, feel part of a larger movement, and create a physical expression of their mental distress.

Although such shrines are in public spaces and the contributions to them form part of collective remembrance, when the display is viewed by visitors and passers-by, there is a high level of individual agency in any engagement with them. These memorial shrines facilitate the expression of personal thoughts and emotions within a community environment. In that sense, they occupy a space between private practices of mourning and veneration that take place at home, on the one hand, and organized ceremonies performed in public spaces especially designated for them, on the other.

Private devotion is both at the core of individual believers' religious experience and largely outside the control and regulation of religious officials. This allows for an element of freedom of choice among the prescribed procedures and rituals, and an aspect of spiritualism. Worship of the gods at home has formed a key part of an individual's relationship with the divine from antiquity until today, across cultures and time periods, whether within major organized religions, on their

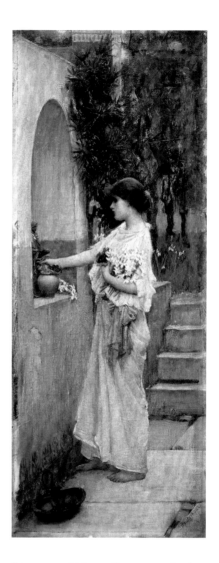

fringes, or within smaller sects and cults. Shared between members of a household and on a fundamental level seeking favorable outcomes for the family, private devotion is an expression of a desire for connection and reassurance, and a search for meaning in life in the face of the unknown and the inexplicable (fig. 69).

Figure 69
John William Waterhouse (English, 1849–1917). *A Roman Offering*, nineteenth century. Oil on canvas, 49.8 x 20.3 cm (19 ⅝ x 8 in.). Private collection.

1 Kaufmann-Heinimann (2007), 188–97. Ancient Mediterranean deities were almost all represented anthropomorphically, frequently as particularly attractive men and women. Their portraits can be identified by certain attributes, such as a trident or a dolphin for the sea god Poseidon or a wine cup for Dionysus, god of wine and theater. Pottery vessels and bronze mirrors decorated with scenes of the gods might have inscribed "captions" naming the figures.

2 Stewart (2003), 195–207, discusses the frequency and significance of gods on lamps.

3 Van Straten (1981), 65–104; Parker (2011), x; Rogers (2012), 16–25.

4 Bremmer (2007); Parker (2011), 124–70. This description corresponds mainly to the Greek practice, but the Roman one was very similar. For more on Roman sacrifice, see Scheid (2007); Beard, North, and Price (1998), 1:148–65.

5 Parker (2011), 127, describes the exchange as "scandalously unequal." We know from surviving comic plays that the Greeks themselves were well aware of this irony.

6 Furley (2007).

7 For dedications by women, see Dillon (2002), 9–36.

8 Van Straten (1981), 81–104, provides a comprehensive discussion of the main motifs.

9 The latter are conventionally known as Tanagra figurines after the city of Tanagra in ancient Boeotia in Greece from which many have been recovered. See Higgins (1986). For terracotta figurines in general, see Uhlenbrock (1990).

10 For general overviews of Greek and Roman religion and suggestions for further reading, see Ogden (2007) and Rüpke (2007), respectively.

11 Belayche (2007), 279.

12 Sigurdsson, Cashdollar, and Sparks (1982).

13 Kaufmann-Heinimann (1998).

14 Hom. Hymn to Aphrodite 21–33. The so-called Homeric Hymns are poems created around the same time as Homer's Iliad and Odyssey, most likely in the mid-eighth century B.C. They recount the life-stories of various deities.

15 Hom. Hymn to Aphrodite 24.

16 Parker (2005), 9–15; Boedeker (2008), 234. Most of our evidence, in the form of vase-paintings and ancient texts, for Hestia and Greek domestic religion in general is from Athens. However, corroborating sources from other city-states allow us to suggest that many practices and beliefs were held by the Greeks more widely.

17 Hamilton (1984); Tsakirgis (2007), 230.

18 Oakley and Sinos (1993).

19 Kaltsas and Shapiro (2008), 295–96.

20 As Blundell (1995), 31, puts it: "While other deities are out and about, Hestia stays at home on Mount Olympus to keep the fires alight: as a result she has very few adventures, and generates only a minimal amount of mythology."

21 See LIMC, vol. 5.1, pp. 407–20, entry "Hestia/Vesta," for a comprehensive discussion of the iconography of the goddess.

22 For the extensive bibliography on the François Vase, see the Beazley Archive (http://www.beazley.ox.ac.uk/databases/pottery.htm). The François Vase is now in the Museo Archeologico Nazionale, Florence.

23 Cohen (2006), 128–29, no. 32.

24 It is not certain that this woman is Hestia, but she is likely a goddess, for she holds a scepter.

25 Parker (2005), 14, n. 24.

26 Cartledge (2009).

27 Sourvinou-Inwood (1990); Parker (2011), 57–61.

28 The Hom. Hymn to Demeter 2.270 tells of the goddess instructing the inhabitants of Eleusis, a city near Athens, to build a temple and an altar for her worship.

29 Parker (2011), x–xi.

30 Kajava (2004); Parker (2005), 403–4.

31 Miller (1978).

32 Schmalz (2006), 33.

33 Tsakirgis (2007), 230.

34 Lefkowitz and Fant (2005), 302.

35 Cahill (2002).

36 Cahill (2002), 154, 156; Jameson (1990), 98, 105; Tsakirgis (2007).

37 Morgan (2007), 302; Parker (2005), 14–15.

38 Foxhall (2007), 240–42.

39 Parker (2005), 42–44.

40 Cox (1998), 130–208.

41 Jameson (1990), 102–3.

42 Cahill (2002), 225–65.

43 Parker (2005), 15–16; Jameson (1990), 104–5; Faraone (2008), 216–17; Boedeker (2008), 230–34.

44 Parker (2005), 21–36.

45 Bodel (2008), 252–55.

46 Wallace-Hadrill (1994), 3–61.

47 On the atrium, see Roberts (2013), 74–115.

48 Several key studies have made this important material accessible: Boyce (1937); Orr (1972). Fröhlich (1991) focuses on the wall-paintings that form part of these shrines.

49 Boyce (1937), 10–18; Orr (1972), 85–97; Beard, North, and Price (1998), 2:102–3; Kaufmann-Heinimann (2007), 197–201. We commonly call these shrines lararia (singular lararium), but in antiquity they were usually called sacella or aediculae.

50 Boyce (1937), 12, n. 6, observes that these stand-alone shrines are similar in design to a type of funerary monument.

51 Kaufmann-Heinimann (1998), 212–13, no. GFV5, fig. 149; Orr (1972), 128–29, 198, no. 26.

52 See the pls. in Fröhlich (1991) for these lively paintings.

53 Dogs are sometimes shown with the Lares, who may also be depicted wearing dog-skin tunics, see Beard, North, and Price (1998), 2:31.

54 Schultz (2006), 13–14, 124; Stek (2009), 187–212.

55 Beard, North, and Price (1998), 1:184–87.

56 Kaufmann-Heinimann (1998) provides an invaluable catalogue and analysis of the bronze figurines of household gods found across Europe.

57 Fröhlich (1991), 279, no. L70, pl. 7.

58 For example, in a shrine from the House of the Red Walls (see fig. 19) the *Lares* wear blue tunics with red mantles, Fröhlich (1991), 291, no. L96, pl. 8.

59 Fröhlich (1991), 292, no. L98, pl. 10.

60 Mattusch (2014), 50, fig. 28.

61 Schultz (2006), 124–25; Orr (1972).

62 Orr (1972), 59–80.

63 See *LIMC*, vol. 5.1, pp. 407–20, entry "Hestia/Vesta," for her limited iconography.

64 Beard, North, and Price (1998), 1:51–54; Beard (1980).

65 Plin. *NH* 36.70; Ov. *Fast.* 6.627–36; Plut. *Fortunes* 10.

66 Kaufmann-Heinimann (1998), 222–23, no. GFV37, fig. 169.

67 Boyce (1937), 36–37.

68 Kaufmann-Heinimann (1998), 210, no. GFV1, fig. 145; Orr (1972), 134.

69 For wooden figurines from Herculaneum, see Roberts (2013), 98–100, figs. 101, 104.

70 Schultz (2006), 121–37; Roberts (2013), 95–100; Clarke (1991), 6–12.

71 Mantle (2002).

72 Boyce (1937), 36; Orr (1972), 95; Roberts (2013), 95–97, fig. 99.

73 Stewart (2003), 195; Boyce (1937), 102, records fourteen cases in which lamps were found in household shrines.

74 Plin. *NH* is also of great value for our understanding of ancient art with its lists of artists and their works.

75 Plut. *Life of Marcellus* 15–17 describes the war machines created by Archimedes and their effectiveness against the Roman forces. Only a long siege and the betrayal of the city ultimately resulted in its capture.

76 Latium was the region of Italy bordering on Rome. It was inhabited by the Latin peoples, the first to become part of the Roman state.

77 For the regions of pre-Roman Italy, see Bradley, Isayev, and Riva (2007).

78 Fox (2008).

79 Wallace-Hadrill (2008), 315–440.

80 See also Plut. *Life of Marcellus* 21.1.

81 Pollitt (1978), 156.

82 Uhlenbrock (1990).

83 Mattusch (2014).

84 Lundgreen (1997).

85 Hallett (2012).

86 See Kousser (2011), 149, on earlier male nudity versus female nudity exemplified by Aphrodite.

87 Bowden (2010), 14–25.

88 Rogers (2012), 3–4.

89 Rogers (2012), 180–83.

90 In this example, these parts as well as the tower on her head are eighteenth-century restorations.

91 Kaufmann-Heinimann (1998), 193.

92 Pollitt (1978), 157–58, 170–74; Pollitt calls Rome "a museum of Greek art"; Carey (2003), 79–82.

93 See Prag and Repath (2009).

94 Wallace-Hadrill (1994), 143–74; Wallace-Hadrill (2008), 356–440.

95 Wallace-Hadrill (2008), 316–18.

96 Kaufmann-Heinimann (2007), 197.

97 Orr (1972), 98–99; while only six shrines from Pompeii are found in the *fauces* itself, sixty-seven are located in the atrium. We can assume that Trimalchio's shrine is in the atrium of his house. For public and private areas in the Roman home, see Wallace-Hadrill (1994).

98 Kaufmann-Heinimann (1998), 212, no. GFV5, fig. 149; Orr (1972), 198, no. 26; Fröhlich (1991), 357.

99 Boyce ([1937], nos. 4, 12, 493) records three silver statuettes (of Isis-Fortuna, Venus *Anadyomene*, and a coiled serpent) from a rural villa, a number of figurines with silver inlays, and statuettes of Jupiter and Mercury holding a silver scepter and herald's staff, respectively.

100 Boyce (1937), 107, records eleven examples under "Venus."

101 Clarke (1998), 145–94. There was no taboo against having women and children exposed to erotic and explicit imagery in the Roman home. Fredrick (1995).

102 Havelock (1995); Ajootian (1996), 98–103; Beard and Henderson (2001), 123–32; Kousser (2011).

103 On the same theme: *Greek Anth.* 16.160, 162–63.

104 McDonald (2011); Karageorghis (2011).

105 Artemis punished the hunter Actaeon for accidently seeing her naked by turning him into a stag that was then ripped apart by his own hunting dogs.

106 Although Pliny later declares Scopas's *Venus* superior to it (Carey [2003], 81).

107 Probably Nikomedes IV, who ruled Bithynia (on the coast of the Black Sea, in present-day Turkey) 94–74 B.C.

108 Pseudo-Lucian *Affairs of the Heart* 11–17 gives a more detailed account of the story.

109 This account is related in Athenaeus *The Learned Banqueters* 13.590–91.

110 Karageorghis (2011).

111 Bartman (1992), 28–29, n. 64, for statuettes in exotic materials.

112 Mander (2012), 1.

113 Clarke (2003), 96–113.

114 Kondoleon and Segal (2011), 129–31.

115 Carroll (2010), 95.

116 Herz (2007), 315.

117 Zanker (1998), 195–201.

118 Gutting (2009), 41.

119 Plin. *Let.* 6.16.5–6.

120 Plin. *Let.* 6.16.9 writes: "He changed his plans, and what he had begun in a spirit of inquiry he completed as a hero. He gave orders for the warships to be launched."

121 Matheson (1994).

122 Stafford (2007), 81–83.

123 Horster (2007), 338–41; Beard, North, and Price (1998), 1:149–56, 214–44.

124 Gager (1992).

125 Plin. *NH* 37.14: "To the greater profit of mankind I shall incidentally confute the abominable falsehoods of the *magi*, since in very many of their statements about gems they have

gone far beyond providing an alluring substitute for medical science into the realms of the supernatural."

126 Plin. *NH* 37.11–13 describes the origins and characteristics of amber. For amber in antiquity, see Causey (2011).

127 Clarke (2003), 96–113.

128 Clarke (2003), 121–23.

129 Roberts (2013), 300, figs. 394–400.

130 Bradley (2005); Stek (2009), 55–58.

131 Bispham (2006), 115–17.

132 Boyce (1937), 36–37.

133 Lapatin (2014).

134 Kaufmann-Heinimann (1998), 168–80.

135 Orr (1972), 99.

136 Roberts (2013), 52, fig. 38, and 60, fig. 54; Fröhlich (1991), 252–53, no. L8, pl. 2.1.

137 Dating to 400–350 B.C., *IG* IV.2.121–22; LiDonnici (1995), 85, A1; Van Straten (1981), 77; see Lefkowitz and Fant (2005), 285–87, for this and other testimonia of the god healing women.

138 Pompeii IX.7.21–22.

139 This wall-painting was removed from the site in 1880 and is now in the collections of the Museo Archeologico Nazionale, Naples. Roberts (2013), 262–64; Boyce (1937), 88, no. 442, pl. 26.2.

140 The goddess is recorded in another latrine painting cited by Boyce (1937), 40–41, no. 122.

141 Orr (1972), 98–99; Boyce (1937).

142 Roberts (2013), 250–52.

143 Wallace-Hadrill (2008), 278: "The typical position of the lararium in the kitchen or service area underlines the role of this cult in the control of the servile household."

144 Lipka (2006), 343–45.

145 For kitchens and toilets, see Roberts (2013), 248–69.

146 Pits found in gardens containing carbonized foodstuffs, such as animal bones, nuts, pine cones, and eggs, may be the remains of household sacrifices; other remnants may have been put into the drains; Roberts (2013), 98.

147 Roberts (2013), 261–62, fig. 325.

148 Boyce (1937), 64, no. 268.

149 See Renberg (2006/2007), 87, n. 1, for different spellings of the god's name.

150 Wickkiser (2008), 11–14.

151 Paus. *Greece* 2.28 mentions that the snakes at Epidaurus "including a peculiar kind of yellowish color" are "tame with men." For patients healed by snakes, see Wickkiser (2008), 47–48.

152 Bremer (1981), 209–11.

153 LiDonnici (1995), 5–14; Dignas (2007), 166–69.

154 See LiDonnici (1995) for these texts and translations.

155 LiDonnici (1995), 97–99, A16, A20.

156 LiDonnici (1995), 95, A12, 97, A17, and 99, A19.

157 LiDonnici (1995), 101, B2.

158 Wickkiser (2008), 18–29.

159 Wickkiser (2008), 53–61.

160 Van Straten (1981), 78.

161 For this practice, which occurred in both Greece and Italy, see Glinister (2000).

162 Van Straten has compiled a valuable appendix of Greek anatomical votives; Van Straten (1981), 97–102, 105–51.

163 Probably also in wax. For a list of gold and silver anatomical votives dedicated at the Athenian Sanctuary of Asclepius, see Van Straten (1981), 108–9.

164 Glinister (2006); Schultz (2006), 102–20.

165 Van Straten (1981), 108–12, 151.

166 Van Straten (1981), 113, no. 2.1, fig. 52.

167 Turfa (2006).

168 Haumesser (2013).

169 Wallace-Hadrill (2008), 357–60.

170 For a Nilotic wall-painting fragment, see *Handbook of the Antiquities Collection* (2010), 223. For the introduction of pearls, see Plin. *NH* 9.59.

171 Wight (2011), 56, fig. 38.

172 Wallace-Hadrill (2008), 357–58. These were part of a longer string of oppression against Egyptian cults at Rome, see De Vos and De Vos (1997), 121.

173 Beard, North, and Price (1998), 2:41–43; Glinister (2000), 62–64.

174 Beard, North, and Price (1998), 2:194–215; Horster (2007).

175 Beard, North, and Price (1998), 2:166–93.

176 Beard, North, and Price (1998), 1:91–96, 160–61, and 2:288–348, 355–56; Schultz (2006), 82–92.

177 On Isis, see Bowden (2010), 156–80; Beard, North, and Price (1998), 2:297–304.

178 Simms (1989).

179 Bowden (2010), 179; Beard, North, and Price (1998), 2:303.

180 Richter (2001), 192, called Plutarch "a good religious historian."

181 Plut. *Isis and Osiris* 3.

182 Boyce (1937), 56–57, no. 220; Orr (1972), 113; Roberts (2013), 99.

183 On Mithras, see Bowden (2010), 181–97; Beard, North, and Price (1998), 2:305–19; Gordon (2007).

184 Beard, North, and Price (1998), 2:316–19.

185 Bodel (2008), 261–62; Visconti (1885).

186 Beard, North, and Price (1998), 2:286–87.

187 Lazaridou (2011), 108, no. 56.

188 Beard, North, and Price (1998), 1:364–75; Cameron (2011).

189 Kaizer (2007), 454–55.

190 Bowes (2011).

191 Perkins (1973), 10–32.

192 For a fascinating view of the shifts in iconography, see Lazaridou (2011).

193 See Van Straten (1981), 148–49, for bibliography on votives from the medieval period and later and Weinryb (forthcoming) for votive practices in different cultures and time periods.

194 Wood (2011).

195 Bagnoli (2010).

196 See http://www.getty.edu/conservation/publications_resources/teaching/case/olita/index.html.

197 Hinnells (1997).

198 Hinnells (1997).

199 Hinnells (1997), Hinduism.

Abbreviations of Ancient Sources

Apul. *Met.*	Apuleius *Metamorphoses*
Cato *Ag.*	Cato *On Agriculture*
Cic. *House*	Cicero *On His House*
Greek Anth.	*The Greek Anthology*
Hes. *Theog.*	Hesiod *Theogeny*
Hom. *Hymns*	*Homeric Hymns* [to various gods]
Hor. *Epist.*	Horace *Epistles*
Hor. *Odes*	Horace *Odes*
IG	*Inscriptiones graecae*
LIMC	*Lexicon iconographicum mythologiae classicae*
Livy *Hist.*	Livy *History of Rome*
Ov. *Fast.*	Ovid *Fasti*
Ov. *Love*	Ovid *Art of Love*
Ov. *Met.*	Ovid *Metamorphoses*
Ov. *Tr.*	Ovid *Tristia*
Paus. *Greece*	Pausanias *Description of Greece*
Petron. *Sat.*	Petronius *Satyricon*
Pl. *Laws*	Plato *Laws*
Plin. *Let.*	Pliny the Younger *Letters*
Plin. *NH*	Pliny the Elder *Natural History*
Plut. *Fortunes*	Plutarch *Fortunes of the Romans*
Plut. *Lives*	Plutarch *Lives* [of various famous people]
Polyb.	Polybius *The Histories*
Suet. *Aug.*	Suetonius *The Deified Augustus*
Suet. *Tib.*	Suetonius *Tiberius*
Tib. *El.*	Tibullus *Elegies*

Ajootian, Aileen. 1996. "Praxiteles." In *Personal Styles in Greek Sculpture*, ed. Olga Palagia and J. J. Pollitt, 91–129. Cambridge.

Bagnoli, Martina, Holger A. Klein, C. Griffith Mann, and James Robinson, eds. 2010. *Treasures of Heaven: Saints, Relics, and Devotion in Medieval Europe*. Cleveland.

Bartman, Elizabeth. 1992. *Ancient Sculptural Copies in Miniature*. Leiden.

Beard, Mary. 1980. "The Sexual Status of Vestal Virgins." *Journal of Roman Studies* 70:12–27.

——, John North, and Simon Price. 1998. *Religions of Rome*, 1–2. Cambridge.

Beard, Mary, and J. Henderson. 2001. *Classical Art: From Greece to Rome*. Oxford.

Belayche, Nicole. 2007. "Religious Actors in Daily Life: Practices and Related Beliefs." In Rüpke 2007:275–91.

Bispham, Edward. 2006. "Coloniam deducere: How Roman Was Roman Colonization during the Middle Republic?" In *Greek and Roman Colonization: Origins, Ideologies, Interactions*, ed. Guy Bradley and J. Wilson, 73–160. Swansea.

Blundell, Sue. 1995. *Women in Ancient Greece*. London.

Bodel, John. 2008. "Cicero's Minerva, *Penates*, and the Mother of the *Lares*: An Outline of Roman Domestic Religion." In Bodel and Olyan 2008:248–75.

——, and Saul M. Olyan, eds. 2008. *Household and Family Religion in Antiquity*. Oxford.

Boedeker, Deborah. 2008. "Family Matters: Domestic Religion in Classical Greece." In Bodel and Olyan 2008:229–47.

Bowden, Hugh. 2010. *Mystery Cults in the Ancient World*. London.

Bowes, Kimberly. 2011. "Christian Worship." In Lazaridou 2011:53–57.

Boyce, George K. 1937. *Corpus of the Lararia of Pompeii. Memoirs of the American Academy in Rome* 14:5–112.

Bradley, Guy. 2005. "Aspects of the Cult of Hercules in Central Italy." In *Herakles and Hercules: Exploring a Graeco-Roman Divinity*, ed. Louis Rawlings and Hugh Bowden, 129–51. Swansea.

——, Elena Isayev, and Corinna Riva. 2007. *Ancient Italy: Regions without Boundaries*. Exeter, UK.

Bremer, J. M. 1981. "Greek Hymns." In *Faith, Hope and Worship: Aspects of Religious Mentality in the Ancient World*, ed. H. S. Versnel, 193–215. Leiden.

Bremmer, Jan N. 2007. "Greek Normative Animal Sacrifice." In Ogden 2007:132–44.

Cameron, Averil. "The Rise of Christianity: From Recognition to Authority." In Lazaridou 2011:32–36.

Cahill, Nicholas. 2002. *Household and City Organization at Olynthus*. London.

Carey, Sorcha. 2003. *Pliny's Catalogue of Culture: Art and Empire in the Natural History*. Oxford.

Carroll, Maureen. 2010. "Exploring the Sanctuary of Venus and Its Sacred Grove: Politics, Cult and Identity in Roman Pompeii." *Papers of the British School at Rome* 78:63–106, 347–51.

Cartledge, Paul. 2009. *Ancient Greece: A History in Eleven Cities*. Oxford.

Causey, Faya. 2011. *Amber and the Ancient World*. Los Angeles.

Clarke, John R. 1991. *The Houses of Roman Italy, 100 B.C.–A.D. 250: Ritual, Space, and Decoration*. Berkeley.

———. 1998. *Looking at Love-making: Constructions of Sexuality in Roman Art, 100 B.C.–A.D. 250*. Berkeley.

———. 2003. *Roman Sex 100 B.C.–A.D. 250*. New York.

Cohen, Beth. 2006. *The Colors of Clay: Special Techniques in Athenian Vases*. Los Angeles.

Cox, Cheryl Anne. 1998. *Household Interests: Property, Marriage Strategies, and Family Dynamics in Ancient Athens*. Princeton.

De Vos, Mariette, and Arnold De Vos. 1997. *Dionysus, Hylas e Isis sui monti di Roma: Tre monumenti con decorazione parietale in Roma antica (Palatino, Quirinale, Oppio)*. Rome.

Dignas, Beate. 2007. "A Day in the Life of a Greek Sanctuary." In Ogden 2007:163–77.

Dillon, Matthew. 2002. *Girls and Women in Classical Greek Religion*. London.

Faraone, Christopher A. 2008. "Household Religion in Ancient Greece." In Bodel and Olyan 2008:210–28.

Fox, Robin Lane. 2008. *Travelling Heroes: Greeks and Their Myths in the Epic Age of Homer*. London.

Foxhall, Lin. 2007. "House Clearance: Unpacking the 'Kitchen' in Classical Greece." In *Building Communities: House, Settlement and Society in the Aegean and Beyond. British School at Athens Studies* 15:233–42.

Fredrick, David. 1995. "Beyond the Atrium to Ariadne: Erotic Painting and Visual Pleasure in the Roman House." *Classical Antiquity* 14:266–88.

Fröhlich, Thomas. 1991. *Lararien- und Fassadenbilder in den Vesuvstädten: Untersuchungen zur 'volkstümlichen' pompejanischen Malerei*. Mainz.

Furley, William D. 2007. "Prayers and Hymns." In Ogden 2007:117–31.

Gager, John G. 1992. *Curse Tablets and Binding Spells from the Ancient World*. Oxford.

Glinister, Fay. 2000. "Sacred Rubbish." In *Religion in Archaic and Republican Rome and Italy: Evidence and Experience*, ed. Edward Bispham and Christopher John Smith, 54–70. Edinburgh.

———. 2006. "Reconsidering 'Religious Romanization.'" In *Religion in Republican Italy*, ed. Paul B. Harvey and Celia E. Schultz, 10–33. Cambridge.

Gordon, Richard. 2007. "Institutionalized Religious Options: Mithraism." In Rüpke 2007:392–405.

Gutting, Edward. 2009. "Venus' Maternity and Divinity in the Aeneid." *Materiali e discussioni per l'analisi dei testi classici* 61:41–55.

Hallett, Christopher. 2012. "The Archaic Style in Sculpture in the Eyes of Ancient and Modern Viewers." In *Making Sense of Greek Art: Ancient Visual Culture and Its Receptions*, ed. Viccy Coltman, 70–100. Exeter, UK.

Hamilton, Richard. 1984. "Sources for the Athenian Amphidromia." *Greek, Roman and Byzantine Studies* 25:243–51.

Handbook of the Antiquities Collection. 2010. The J. Paul Getty Museum. Los Angeles.

Haumesser, Laurent. 2013. "Archaeologie et anatomie: Un Buste votif étrusque au Musée du Louvre." *Revue du Louvre et des Musées de France* (December):16–23, figs. 13–14.

Havelock, Christine Mitchell. 1995. *The Aphrodite of Knidos and Her Successors*. Ann Arbor, MI.

Herz, Peter. 2007. "Emperors: Caring for the Empire and Their Successors." In Rüpke 2007:304–16.

Higgins, R. A. 1986. *Tanagra and the Figurines*. London.

Hinnells, John R. 1997. *A New Handbook of Living Religions*. Oxford.

Horster, Marietta. 2007. "Living on Religion: Professionals and Personnel." In Rüpke 2007:331–41.

Jameson, Michael H. 1990. "Domestic Space in the Greek City-State." In *Domestic Architecture and the Use of Space: An Interdisciplinary Cross-cultural Study*, ed. Susan Kent, 92–113. Cambridge.

Kaizer, Ted. 2007. "Religion in the Roman East." In Rüpke 2007, 446–56.

Kajava, Mika. 2004. "Hestia: Hearth, Goddess, and Cult." *Harvard Studies in Classical Philology* 102:1–20.

Kaltsas, Nikos E., and H. Alan Shapiro, eds. 2008. *Worshiping Women: Ritual and Reality in Classical Athens*. New York.

Karageorghis, Jacqueline. 2011. "The Cypriot Origin of Aphrodite." In Kondoleon and Segal 2011:28–33.

Kaufmann-Heinimann, Annemarie. 1998. *Götter und Lararien aus Augusta Raurica: Herstellung, Fundzusammenhänge und sakrale Funktion figürlicher Bronzen in einer römischen Stadt*. Augst.

———. 2007. "Religion in the House." In Rüpke 2007:188–201.

Kondoleon, Christine, and Phoebe C. Segal, eds. 2011. *Aphrodite and the Gods of Love*. Boston.

Kousser, R. 2011. "The Female Nude in Classical Art: Between Voyeurism and Power." In Kondoleon and Segal 2011:149–66.

Lapatin, Kenneth D. S., ed. 2014. *The Berthouville Silver Treasure and Roman Luxury*. Exh. cat. Los Angeles.

Lazaridou, Anastasia, ed. 2011. *Transition to Christianity: Art of Late Antiquity, 3rd–7th Century A.D*. New York.

Lefkowitz, Mary R., and Maureen B. Fant. 2005. *Women's Life in Greece and Rome: A Source Book in Translation*. 3rd edition. Baltimore.

LiDonnici, Lynn R. 1995. *The Epidaurian Miracle Inscriptions*. Atlanta, GA.

Lipka, Michael. 2006. "Notes on Pompeian Domestic Cults." *Numen* 53:327–58.

Lundgreen, Birte. 1997. "A Methodological Enquiry: The Great Bronze Athena by Pheidias." *The Journal of Hellenic Studies* 117:190–97.

McDonald, Diana K. 2011. "Ancient Near Eastern Goddesses of Love." In Kondoleon and Segal 2011:17–25.

137

Mander, Jason. 2012. *Portraits of Children on Roman Funerary Monuments*. Cambridge.

Mantle, I. C. 2002. "The Roles of Children in Roman Religion." *Greece and Rome*, 2nd Series, 49:85–106.

Matheson, Susan B. 1994. "The Goddess Tyche." In Susan B. Matheson, *An Obsession with Fortune: Tyche in Greek and Roman Art*, 18–33. New Haven, CT.

Mattusch, Carol C. 2014. *Enduring Bronze: Ancient Art, Modern Views*. Los Angeles.

Miller, Stephen G. 1978. *The Prytaneion: Its Function and Architectural Form*. Berkeley.

Morgan, Janett. 2007. "Women, Religion, and the Home." In Ogden 2007:297–310.

Oakley, John Howard, and Rebecca H. Sinos. 1993. *The Wedding in Ancient Athens*. Madison, WI.

Ogden, Daniel, ed. 2007. *A Companion to Greek Religion*. Malden, MA.

Orr, David Gerald. 1972. "Roman Domestic Religion: A Study of the Roman Household Deities and Their Shrines at Pompeii and Herculaneum." Ph.D. diss., University of Maryland.

Parker, Robert. 2005. *Polytheism and Society at Athens*. Oxford.

———. 2011. *On Greek Religion*. Ithaca, NY.

Perkins, Ann Louise. 1973. *The Art of Dura-Europos*. Oxford.

Pollitt, Jerome J. 1978. "The Impact of Greek Art on Rome." *Transactions of the American Philological Association* 108:155–74.

Prag, Jonathan, and Ian Repath, eds. 2009. *Petronius: A Handbook*. Malden, MA.

Renberg, Gil H. 2006/2007. "Public and Private Places of Worship in the Cult of Asclepius at Rome." *Memoirs of the American Academy in Rome* 51/52:87–172.

Richter, Daniel S. 2001. "Plutarch on Isis and Osiris: Text, Cult, and Cultural Appropriation." *Transactions of the American Philological Association* 131:191–216.

Roberts, Paul. 2013. *Life and Death in Pompeii and Herculaneum*. London.

Rogers, Guy MacLean. 2012. *The Mysteries of Artemis of Ephesos: Cult, Polis, and Change in the Graeco-Roman World*. New Haven, CT.

Rüpke, Jörg, ed. 2007. *A Companion to Roman Religion*. Malden, MA.

Scheid, J. 2007. "Sacrifices for Gods and Ancestors." In Rüpke 2007:263–71.

Schmalz, Geoffrey C. R. 2006. "The Athenian Prytaneion Discovered?" *Hesperia* 75:33–81.

Schultz, Celia E. 2006. *Women's Religious Activity in the Roman Republic*. Chapel Hill, NC.

Sigurdsson, Haraldur, Stanford Cashdollar, and Stephen R. J. Sparks. 1982. "The Eruption of Vesuvius in A.D. 79: Reconstruction from Historical and Volcanological Evidence." *American Journal of Archaeology* 86:39–51.

Simms, Ronda R. 1989. "Isis in Classical Athens." *The Classical Journal* 84:216–21.

Sourvinou-Inwood, Christine. 1990. "What Is Polis Religion?" In *The Greek City: From Homer to Alexander*, ed. Oswyn Murray and S. R. F. Price, 295–323. Oxford.

Stafford, Emma. 2007. "Personification in Greek Religious Thought and Practice." In Ogden 2007:71–85.

Stek, Tesse. 2009. *Cult Places and Cultural Change in Republican Italy: A Contextual Approach to Religious Aspects of Rural Society after the Roman Conquest*. Amsterdam Archaeological Studies 14. Amsterdam.

Stewart, Peter. 2003. *Statues in Roman Society: Representation and Response*. Oxford.

Tsakirgis, Barbara. 2007. "Fire and Smoke: Hearths, Braziers and Chimneys in the Greek House." In *Building Communities: House, Settlement and Society in the Aegean and Beyond*. British School at Athens Studies 15:225–31.

Turfa, Jean M. 2006. "Votive Offerings in Etruscan Religion." In *The Religion of the Etruscans: Proceedings of the Sixth Langford Conference, Florida State University, 1999*, ed. Nancy T. De Grummond and Erika Simon, 90–115. Austin, TX.

Uhlenbrock, Jaimee Pugliese. 1990. *The Coroplast's Art: Greek Terracottas of the Hellenistic World*. New Paltz, NY.

Van Straten, Folkert T. 1981. "Gifts for the Gods." In *Faith, Hope and Worship: Aspects of Religious Mentality in the Ancient World*, ed. H. S. Versnel, 65–151. Leiden.

Visconti, Carlo L. 1885. "Del larario e del mitrèo scoperti nell'Esquilino presso la chiesa di S. Martino ai Monti." *Bullettino della Commissione Archeologica Comunale di Roma* 13:27–36.

Wallace-Hadrill, Andrew. 1994. *Houses and Society in Pompeii and Herculaneum*. Princeton.

———. 2008. *Rome's Cultural Revolution*. Cambridge.

Weinryb, Ittai, ed. Forthcoming. *Ex Voto: Votive Giving across Cultures*.

Wickkiser, B. L. 2008. *Asklepios, Medicine, and the Politics of Healing in Fifth-century Greece: Between Craft and Cult*. Baltimore.

Wight, Karol. 2011. *Molten Color: Glassmaking in Antiquity*. Los Angeles.

Wood, Christopher S. 2011. "The Votive Scenario." *Anthropology and Aesthetics* 59/60:206–27.

Zanker, Paul. 1998. *The Power of Images in the Age of Augustus*. Trans. Alan Shapiro. Ann Arbor, MI.

138

142

Published by the J. Paul Getty Museum, Los Angeles
Getty Publications
1200 Getty Center Drive, Suite 500
Los Angeles, California 90049-1682
www.getty.edu/publications

Benedicte Gilman, *Project Editor*
Kurt Hauser, *Designer*
Elizabeth Chapin Kahn, *Production*

Distributed in the United States and Canada by the
University of Chicago Press

Distributed outside the United States and Canada by
Yale University Press, London

Printed in China

Library of Congress Cataloging-in-Publication Data
Sofroniew, Alexandra, author.
 Household gods : private devotion in ancient Greece and Rome /
Alexandra Sofroniew.
 pages cm
 Includes bibliographical references and index.
 ISBN 978-1-60606-456-6 (hardcover)
 1. Gods, Greek. 2. Gods, Roman. 3. Greece—Religious life and customs.
4. Rome—Religious life and customs. 5. Household shrines—Greece.
6. Household shrines—Rome. 7. Votive offerings—Greece. 8. Votive
offerings—Rome. I. J. Paul Getty Museum, issuing body. II. Title.
 BL723.S64 2015
 292.2'11—dc23
 2015029969

Front Cover: Statuette of Hygeia. Roman, first half of the second century
 A.D. (detail, fig. 55)

Back Cover: (top) *Lararium* (household shrine) from the House of the
 Vettii (VI.15.1) in Pompeii (fig. 14); (bottom) Crouching Aphrodite. Greek
 (Ptolemaic) or Roman, first century B.C. (fig. 34)

Page i: *Lararium* with an armed Minerva and depiction of a snake-shaped
 demon. Roman, from Villa Carmiano at Castellammare di Stabia, first
 century A.D. Plaster and pigment. Stabia, Archaeological Museum

Page ii: John William Waterhouse (British, 1849–1917), *The Household
 Gods*, about 1880 (detail, fig. 22)

Page iv: Detail of statuette of Hercules. Roman, A.D. 40–70. Bronze with
 silver-inlaid eyes. JPGM, acc. 96.AB.185

Page v: Detail of wall-painting of a young girl with a plate of offerings in the
 Villa of the Mysteries. Roman (from Pompeii), first century B.C. Plaster
 and pigment

Page 13: Statuette of Mars Ultor (the Avenger). Roman, second century
 A.D. (detail, fig. 30)

Page 14: Detail of statuette of Phrixos. Roman, first century B.C. Bronze.
 JPGM 58.AB.6

Page 26: Statuette of a *Lar*, the *Genius* of Aurelius Valerius. Roman, third
 century A.D. (detail, fig. 17a)

Page 46: Statuette of Diana (Artemis) of Ephesus. Roman, second century
 A.D. (detail, fig. 29)

Page 62: Statuette of Aphrodite leaning on a column. Greek, 250–200 B.C.
 (detail, fig. 33)

Page 78: Statuette of Mercury. Gallo-Roman, A.D. 120–140 (detail, fig. 46)

Page 92: Statuette of Aesculapius. Roman, first half of the second century
 A.D. (detail, fig. 54)

Page 106: Statuette of Isis-Fortuna. Roman, second century A.D. (detail,
 fig. 59)

Page 122: Modern home altar on a street wall in Venice, Italy, 2009.
 Photographer: Jorge Royan

Illustration Credits

Pages i, v, fig. 48: De Agostini Picture Library / G. Dagli Orti / Bridgeman
 Images

Page ii, figs. 22, 69: © Christie's Images / Bridgeman Images

Figs. 2, 12, 17a–b, 23–24, 27–28, 40, 54–55: Bruce White

Fig. 4: © Hellenic Ministry of Culture, Education, and Religious Affairs /
 Archaeological Receipts Fund. Photographer: Giannis Patrikianos

Fig. 9: © 2016 Museum of Fine Arts, Boston

Figs. 10–11, 37: © The Trustees of the British Museum / Art Resource, NY

Fig. 14: De Agostini Picture Library / W. Buss / Bridgeman Images

Fig. 15: Su concessione del Ministero dei Beni e delle Attività Culturali e del
 Turismo. Soprintendenza speciale per Pompei Ercolano e Stabia

Fig. 18: De Agostini Picture Library / L. Romano / Bridgeman Images

Figs. 21, 57: The Walters Art Museum, Baltimore

Fig. 31: Fotografica Foglia / Scala / Art Resource, NY

Fig. 43: Bridgeman Images

Fig. 49: © Vanni Archive / Art Resource, NY

Fig. 50: © Ashmolean Museum, University of Oxford

Fig. 51: DeA Picture Library / De Agostini / Getty Images

Fig. 52: © Hellenic Ministry of Culture, Education, and Religious Affairs.
 Photographer: Athanasios Meliarakis

Fig. 58: Scala / Art Resource, NY

Figs. 62a–b: Yale University Art Gallery, Dura-Europos Collection

Page 122, fig. 68: Jorge Royan / CC BY-SA 3.0

Fig. 64: Erich Lessing / Art Resource, NY

Figs. 66a–b: Wouter Hagens / CC BY-SA 3.0